SHIVERING BABE, VICTORIOUS LORD

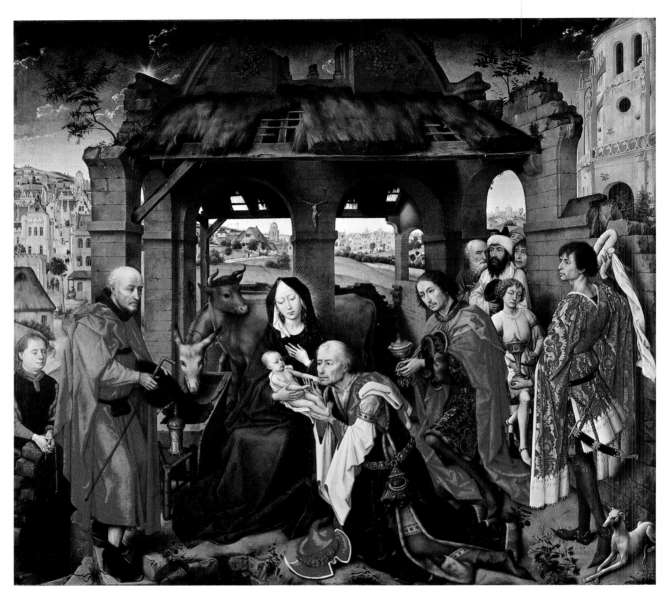

Plate 1. *Rogier van der Weyden,* Adoration of the Magi *(c. 1460)*
Painting in an era when the Nativity stood as the cornerstone of a common Western Christendom, the great Flemish master places the venerated mother and child at the center of fifteenth-century society, both royal and common. The centrality of the event in the history of salvation is noted by the crucifix suspended above the child, who is both shivering babe and victorious Lord. Alte Pinakothek, Munich (Scala, New York/Florence)

SHIVERING BABE, VICTORIOUS LORD

The Nativity in Poetry and Art

by
LINDA CHING SLEDGE

WILLIAM B. EERDMANS PUBLISHING COMPANY
GRAND RAPIDS, MICHIGAN

To my husband, Gary

Library of Congress Cataloging in Publication Data:
Main entry under title:
Shivering Babe, victorious Lord.
1. English poetry. 2. American poetry. 3. Jesus
Christ — Poetry. I. Sledge, Linda Ching, 1944-
PR1195.J4S5 821'.008'0382 81-9728
ISBN 0-8028-3553-8 AACR2

CONTENTS

I. THE FOURTEENTH AND FIFTEENTH CENTURIES 3

II. THE SIXTEENTH CENTURY 39

III. THE SEVENTEENTH CENTURY 75

LIST OF PLATES

PREFACE

THIS book records the history of a relationship.

It is not a book of ancient Christmas customs or legends or "best-loved" carols and songs. My original intent was to trace a pivotal and long-ignored theme in English literature, the birth and infancy of Jesus. But I found I was also chronicling a fascinating alliance between ordinary people and Christ. As that intimacy altered over the centuries, so did the poems. The relationship was at times so intense that the infant mirrored the actual features of the folk. In the late Middle Ages, for example, the shivering, weeping babe is a salient image of the people's penitence and pain in an era torn by warfare, economic upheaval, and plague. At other times, the bond is more attenuated, as in the nineteenth century, which saw religious tradition challenged by faith in science and the Christ child little more than a quaint, doll-like figure. Yet no matter how tenuous the tie, it remains unsevered. It persists even in this secularized, individualistic age between skeptical modern Christians and an infant Christ who has become an agent of history, reminding mankind of an imminent judgment by God.

In this partnership, the Nativity theme is a particularly sensitive barometer measuring changes in religious as well as in literary history. This is history as lived by common people, not princes, popes, or prelates. And in that often turbulent marriage between Christ and his people, it is their voice that is clearly heard through the poet's pen, proclaiming an impossible joy in the face of impending death.

The chronicler of such a rich saga has many advantages. There is a wealth of material from which to draw. In the seventeenth century, for example, virtually every major poet from Donne to Vaughan writes brilliantly on the theme. Nevertheless, there are special problems too. Two of them should be mentioned because they account for this book's structure. Along with the abundance of materials, there are a great disparity of bulk and a diversity of treatment over the centuries. The Middle Ages produced an enormous amount of verse on the birth of Christ. That tradition was refined until it achieved a level of unsurpassed artistry in the

late Renaissance. Thereafter, the quantity and quality of the works fall off sharply until the beginning of this century, when the theme undergoes a notable poetic revival. This accounts for my somewhat uneven treatment of historical and literary periods. I have paid great attention to the era up through the seventeenth century and have condensed the material on the eighteenth and nineteenth centuries, when fewer poems were produced. Another problem was to decide which poems to include. Although the eighteenth century, the "Golden Age" of hymnody, produced a large number of Nativity hymns and songs, these were primarily in the vein of ecclesiastical polemic and have little merit as belles lettres. So I have largely exempted eighteenth-century Christmas carols here. I have, however, included many poems of literary value and interest by poets whose religious orthodoxy may be questionable. These works are of interest to me because they point to the great richness of the theme and its remarkable ability to lend meaning to secular or non-Christian perspectives. This diversity allows us to see the Nativity in a fresh new light and to glimpse surprising connections between artists over the years. We note, for example, that the young King Henry VIII's Christmas song, "Green Groweth the Holly," is a witty garland of ancient pagan motifs in Christian dress. Or that Blake's "A Cradle Song" is a secular version of the traditional medieval lullaby to the Christ child.

This work is a scaled-down version of an earlier unpublished scholarly treatise on the same subject. Vast areas of history are thus missing and even vaster areas of literary history are briefly condensed, since I have limited myself to representative poems on a single theme. I have profited from the works of many distinguished historians and literary critics, but the interpretations herein are my own.

Pleasantville, New York
March 1981

ACKNOWLEDGMENTS

SPECIAL, heartfelt thanks are due to the following: Miriam Starkman, my teacher, who suggested the topic and gave authoritative, sympathetic direction in its first life as a doctoral dissertation; John Flynn, who read the manuscript with a historian's keen eye and offered valuable suggestions; Anne Schotter, who read and criticized the literature portions of the work closely; Norman Campbell, who came to my aid with an expert translation of Erasmus's Latin hymn; Gary Sledge, who helped me at every stage of the work and was my most stringent and diligent critic. I am also indebted to the Andrew Mellon Foundation and the Graduate Center of the City University of New York for their support during the final stage of writing.

Grateful acknowledgment is made to the following for permission to reprint material from their publications:
for "The Magi," "The Second Coming," and "The Mother of God," from *The Collected Poems of W. B. Yeats*, copyright © 1916, 1924, 1933 by Macmillan Publishing Co., Inc., renewed 1944, 1952, 1961 by Bertha Georgie Yeats, reprinted by permission of Macmillan Publishing Co., Inc., and by permission of M. B. Yeats, Anne Yeats, and Macmillan London Ltd.; for "Gerontion" and "Journey of the Magi," from *Collected Poems, 1909 – 1962* by T. S. Eliot, copyright © 1936 by Harcourt Brace Jovanovich, Inc., renewed 1963, 1964 by T. S. Eliot, reprinted by permission of Harcourt Brace Jovanovich, Inc. and Faber and Faber Ltd.; for *For the Time Being: A Christmas Oratorio*, from *W. H. Auden: Collected Poems* by W. H. Auden, ed. by Edward Mendelson, copyright © 1944, renewed 1972 by W. H. Auden, reprinted by permission of Random House, Inc., and Faber and Faber Ltd.; for "Still Falls the Rain" and "Lullaby," from *Collected Poems* by Edith Sitwell, reprinted by permission of Vanguard Press and by permission of Macmillan London Ltd.; for "More Sonnets at Christmas, II and III," from *Allen Tate: Collected Poems, 1919 – 1976*, copyright © 1952, 1953, 1970, 1977 by Allen Tate, copyright 1931, 1933, 1937, 1948 by Charles Scribner's Sons, renewed 1959, 1960, 1965 by Allen Tate, reprinted by permission of Farrar,

Straus and Giroux, Inc., and from *The Swimmer and Other Selected Poems* by Allen Tate, copyright © 1970 by Allen Tate, reprinted by permission of Oxford University Press; for "Carol of the Brown King," copyright © 1958 by the Crisis Publishing Company, reprinted by permission of Harold Ober Associates, Inc.; for "Christ Climbed Down," from *A Coney Island of the Mind* by Lawrence Ferlinghetti, copyright © 1958 by Lawrence Ferlinghetti, reprinted by permission of New Directions; for "The Holy Innocents," from *Lord Weary's Castle*, copyright © 1946, renewed 1974 by Robert Lowell, reprinted by permission of Harcourt Brace Jovanovich, Inc., and from *Poems: 1938—49* by Robert Lowell, reprinted by permission of Faber and Faber Ltd. We also express our thanks to the Museum of Modern Art, New York, for Picasso's *Guernica* (1937, May-early June), oil on canvas, 11′5½″ x 25′5¾″, on extended loan to the museum from the estate of the artist, and to the Metropolitan Museum of Art, New York, for Gauguin's *Ia Orana Maria*, copyright © 1978 by the Metropolitan Museum of Art.

Shivering Babe, Victorious Lord

The Nativity in Poetry and Art

I *The Son of Man Is God Be-Come*

THE FOURTEENTH AND FIFTEENTH CENTURIES

THE END OF CHIVALRY

THE first Nativity poems in the English language were homely, pious works mirroring the harsh lives of common folk during the fourteenth and fifteenth centuries, an era scarred by recurrent civil and religious turmoil. These poems offer rich, varied interpretations of the late medieval devotion to a human Christ and range from morbidity to idealism, from adoration to irreverence. Their prevailing tone is grim; their depiction of the Nativity starkly naturalistic. Yet hope and ardor abound in these lyrics. The sufferings of a tiny Christ seemed to bestow a transcendent purpose upon the brutal reality of the waning Middle Ages, when the old feudal order that had dominated English society since William the Conqueror had begun to crumble under the successive onslaught of war and disease.

It was an age of endings. In 1396, the last Crusade against the infidel had ended in disaster for the Christian army at Nicopolis on the Black Sea. This brutal, bloody rout closed the romantic saga of Anglo-Norman history in "Outremer," the splendid, cosmopolitan Crusader world that stretched across the islands of the "Middle Sea" to the Holy Land itself. On the heels of the last Crusade came the end of the Hundred Years' War with France, and England's bitter defeat by the rejuvenated House of Valois. By 1453, England's once proud Plantagenet dynasty had collapsed. King Henry VI had gone mad. Only Calais remained as the final bastion of English suzerainty on French soil. Chroniclers like John Froissart saw the Hundred Years' War as the supreme embodiment of chivalric ideals, with heroes like the Black Prince, who had won his spurs in hand-to-hand combat on the field at Crécy, sharing the laurels of the fabled Arthur and Lancelot. Yet in truth, the Hundred Years' War was a long, sordid contest full of misery and trickery. In the end, the prerogatives of knighthood did little to soften the very real horrors of war for the common people.

Men of faith began to seek less violent means of religious expression, turning from bloody coercion to the establishment of world-wide missions as the means of converting the infidel or laying claim to new territory. The mantle of the revered Richard Coeur-de-Lion soon fell to more pious and pacific heroes modeled on the impassioned asceticism of St. Francis of Assisi. One such hero was the fourteenth-century English mystic Richard Rolle, who wrote fervently of the fires of divine love, not the conflagrations of battle.

The Black Death, too, wrote its own denouement on the age and, like a deadly scythe, cut a wide swath through the lower classes. Carried from the East by flea-infested rats in the holds of merchant ships, the bubonic plague reached the city that is now called Weymouth by the mid-fourteenth century. In a few short months, over a third of the English population had fallen to this "Great Mortality," which marked its victims with unsightly purple and black spots. One particularly virulent form of the disease attacked the lungs and could be easily passed through the victims' breath. Thus, people contracted the disease not only from rats and fleas, but from the embraces of loved ones; the grand medieval themes of Love and Death had their source in a grim reality. The poor, laboring classes, the bulwark of feudal society, bore the brunt of the plague. Encouraged by Pope Clement VI, the terror-stricken people joined together in huge processionals leading from their cramped, unhealthy homes to drafty, filthy cathedrals to beg God for deliverance. Ironically, this allowed the pestilence to spread with even more fatal alacrity. Soon the great proportion of the serfs lay buried in the mass graves set aside for plague victims. And the backbone of feudalism, with its complex system of loyalty and necessity anchoring serf to the land and to his lord, was broken. Henceforth, many of the surviving serfs would command higher wages and would emerge as a new breed of rural working class, laboring for wages where and for whom they chose.

THE RISE OF THE LAITY

History has been written as the record of kings. For men and women of the late Middle Ages, however, the births and deaths of kings had little meaning. Although the lot of the English serf was far more secure than that of the *vilain* of France, still, the serf's life was played out against a backdrop of unremitting social instability and deprivation. It is not surprising that the transience of human affairs — the biblical *vanitas* theme of Ecclesiastes — preoccupied the minds of most people during this time. One of the most familiar motifs in medieval art was the

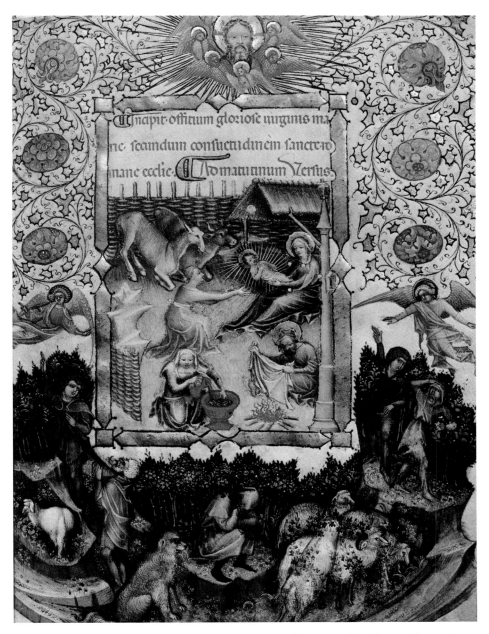

Plate 2. *Balbello da Pavia,* Nativity *(manuscript illustration, late fourteenth cent.) Da Pavia's scene includes homely details that underscore the natural reality of the Nativity for late medieval Christians, while at the same time it depicts the supernatural legend of the kneeling animals. The framing scenes suggest the cosmic and especially redemptive ramifications of this birth. National Library, Florence (Scala, New York/Florence)*

danse macabre, a procession of skeletal princes and paupers snake-dancing gro-
tesquely across the painted walls of great cathedrals. People believed that the
destinies of courtier, cleric, peasant, and philosopher were governed by the beau-
tiful but fickle goddess Fortuna, who would send men and women to riches or to
ruin with a flick of her ever-spinning wheel:

> When Fortune list* you her assent, *gives*
> Who is to deem what may be done?
> There shapeth nought from her intent,
> For as she will it goeth there-to;
> All passeth by her judgment,
> The high estate, the poor also.
>
> To live in joy out of torment,
> Seeing the world goeth to and fro —
> Thus is my short advisement,
> As it cometh, so let it go!

What manner of men and women accepted so unquestioningly the hold of
Fortuna, the cruel, capricious pagan deity, over their lives? Beneath the outward
forms of discipline and prayer there ran a deep vein of emotionalism in medieval
society that swung in violent, unexpected arcs. The medieval laity could delight
in the spectacle of an execution and consider it food for their souls, while at
another moment they could weep at the pious words of a convicted murderer,
forgive him his crime, and commend him for his brave death. Hundreds at a time
could be moved to burn their few articles of luxury by the incendiary words of
mendicant friars, the gifted, pious men who wrote the tender, bittersweet carols
and ballads commemorating the birth of Jesus Christ.

Outwardly, commoners led the same strict life of toil that their ancestors
had four hundred years before in the time of William the Conqueror. As they
had since the early Middle Ages, the people of countryside and town formed the
largest stratum of medieval society. The average fourteenth-century peasant was
still chained to the land. If he was a serf, the least enfranchised of the peasant
class, all his possessions belonged technically to his lord. He plowed three days
a week in his master's field. He was taxed mercilessly at his lord's whim. He paid
to have his bread baked in his lord's ovens and his corn ground in his lord's mills.
If his daughter married or if he sold a beast for profit, the master collected a
fine. At the serf's death, his lord confiscated his best chattel. The serf, his wife,

or his sons and daughters could be sold along with their property to another master at any time.

Yet by the end of the fourteenth century, this static feudal system had become much more fluid and dynamic, for the character of town and countryside was rapidly being transformed. Just as the Black Death had left many rural towns empty and in disrepair, so the War of the Roses, in its turn, ruined many noble families. Both hastened the breakup of large feudal estates and gave the lower classes more opportunity to achieve independence. Many former serfs prospered through prudence and industry and were able to buy freedom and respectability for themselves and their children. Over the next century and a half, a vigorous commercial class emerged to swell the ranks of a new "class" of landed commoners upon whose loyalty and service the great Tudor monarchy came to depend.

The dissolving bands between vassal and lord led to a strong community sense that bound together the inhabitants of villages and towns. The late Middle Ages attests to the English commoners' tough resistance to servitude, despite the high cost of such resistance. When it was found that a handful of burgesses in Bristol had been caught cheating the citizenry, the outraged townspeople rose against them in 1314 with "fists and sticks." Even after eighty citizens were indicted, the town refused to obey a royal mandate to surrender the guilty and hid the men within the well-fortified town walls.

A more notorious example of civil disobedience occurred in 1381 when English peasants, stung by the harsh poll tax levied by the crown for a fruitless war in France, staged a nearly successful revolution against fourteen-year-old King Richard II and his advisors. Led by the fiery prelate John Ball and the Kentish rebel Wat Tyler, angry serfs marched on London, killing the Archbishop of Canterbury and very nearly toppling Richard's already shaky throne. As they rampaged through the streets of London, the peasants chanted a sardonic, antiaristocratic slogan:

> When Adam delved and Evë span
> Who was then the gentleman?

The uprising was brutally suppressed by Richard, who would go down in history as the vacillating, martyred sovereign of Shakespeare's chronicle play *Richard II*. Although the young king treacherously rescinded the vow to abolish serfdom that he had made under duress, the serf was never to be so cruelly abused as he had been in earlier days.

THE HOLY BEGGARS

War, plague, and an unruly class of poor people gave rise to an upsurge of pietism, a genuine and widespread spiritual revival that made itself felt in the waves of "pious beggars" who flooded England's shores from the thirteenth to the fifteenth centuries. These were the mendicant friars — Carthusians, Cistercians, the eloquent Dominicans, and Franciscans — who, dismayed by the waste of human life in the Crusades, set forth from the continent to roam the globe and win men to Christ through the gentle art of preaching. In the hands of these able, often unschooled *clercs*, Holy Scripture became living, oral history. They moved easily among the people, disseminating and dramatizing the stories in the Bible in the people's own idiom. Geoffrey Chaucer's portrait of the fourteenth-century parson in the prologue to the *Canterbury Tales* depicts a man of humility and kindliness who gladly spent his talents in living for others:

> Wide was his parish and houses far asunder,
> But he ne left not, for rain nor thunder,
> In sickness nor in meschief to visit
> The farthest in his parish, muche and lite,* *great and small*
> Upon his feet, and in his hand a staff
> This noble example to his sheep he yaf,* *gave*

Chaucer's parson is a heartfelt, simply drawn tribute to the spiritual gaiety of these men who dubbed themselves *joculatores domini*, God's jesters, and who could find no nobler or fairer a bride than Lady Poverty.

The reform movement in the late medieval Catholic Church was the inspiration of the charismatic young layman, Giovanni Francesco Bernardone, later known as St. Francis of Assisi. He was not an intellectual, and although born to wealth, he became an active man of the multitude, using his natural gift for oratory to tap the commoners' enormous yearning for a deity in their own image. St. Francis and his band of roving, itinerant brothers kept no homes in the early days of the movement, but traveled from one village to the next, working in the fields or at odd jobs, depending on the charity of Tuscan peasants for food and shelter. They found joy and kinship in nature. St. Francis's biographers marvel at his remarkable intimacy with creatures, especially birds, for whom he reserved a special affection. Even as the splendors of the physical world faded before his stricken eyes, the dying St. Francis continued to sing in praise of nature's wonder and God's munificence. On his rude deathbed, the holy man composed the mag-

nificent "Canticle of the Sun," a moving tribute to "our brother the Sun," "our sister the Moon," and "our mother the Earth," a rhapsody springing from the depths of this gentle and complex man's soul. The feast of the Nativity had a special appeal for St. Francis, and he transformed the birth of the infant Jesus into a living mystery for the common folk, into a compelling drama in which present history intersected the sacred. The simple religious tunes, or *laudi*, that St. Francis and his followers were accustomed to sing to the baby Jesus were transplanted onto English soil as the bittersweet, haunting refrain-song, the medieval Christmas carol.

St. Francis's influence is especially strong in the English Nativity carol, which, like the Italian *lauda*, depicts popular interpretations of the gospel records of Christ's infancy and childhood. Most medieval carols preserved in manuscript form were written by English Franciscans for use as sermon illustrations, as *intermezzi* sung between acts of the popular religious drama, or for festive group singing. The pious outlook of the medieval *clerc* did not necessarily mean that carols offered only sober church doctrine. The *clerc* may not have been a learned doctor, but he had a ready grasp of biblical stories, a rudimentary knowledge of Latin, and a good memory for passages from the liturgy as well as an intimate knowledge of the homely values, music, and superstitions of the common folk among whom he moved so freely. Thus, from its first introduction into English literature in the mid-fourteenth century, the carol sang of many things: certainly sober religious themes like the Passion or the events surrounding Christ's birth, but also "profane" themes that pricked the hearts of laypeople, such as the joys and sorrows of love, the fickleness of womankind, and, occasionally, an unsettling but culturally sanctioned medieval anti-semitism. The Nativity carols in particular display a lightheartedness that points to the persistence of pagan and folk beliefs governing even the *clerc*'s perception of the Christmas holy day.

Lauda and carol were sung by friars, minstrels, and layfolk at court or at castle, at rectory or on village green. But the songs became increasingly associated with the Franciscan custom of the crèche, the reenactment of the Bethlehem cradle scene, drawn from the pages of Luke and Matthew. Setting aside the church's strictures against *ludi theatrales*, religious "games" or performances, Pope Innocent III himself gave St. Francis special permission to perform the first Christmas tableau in 1223. A hermit's cave deep in the woods of Greccio, Italy, was chosen as the theatrical site. Joyfully, the villagers of Greccio went to work cutting torches, clearing the glade for the audience, and memorizing the actors' parts. St. Francis had set the humble folk afire with his own incandescent vision of the

HAND BY HAND WE SHALL US TAKE

Refrain Hand by hand we shall us take,
And joy and blissë shall we make,
For the devil of hell man hath forsake,
And Goddès son is maked our make.* *made our mate*

A child is born amongès man,
And in that child was no wam;* *blemish*
That child is God, that child is man,
And in that child our life began.

Sinful man be blithe and glad,
For your marriage thy peace is grad,* *prepared*
 When Christ was born:
Come to Christ, thy peace is grad,
For thee was his blood y-shed,
 That were forlorn.

Sinful man be blithe and bold,
For heaven is both bought and sold
 Every foot:
Come to Christ, thy peace is told,
For thee he gave a hundredfold
 His life to bote.* *as a remedy*

LULLAY MINE LIKING

Refrain Lullay mine liking, my dear son, mine sweeting,
Lullay my dear heart, mine own dear darling.

I saw a fair maiden
Sitten and sing,
She lullèd a little child,
A sweetë lording.

That eche* lord is he *eternal*
That made allë thing;
Of allë lordès he is lord,
Of allë kingès king.

There was mickle* melody *much*
At that childès birth.
All that were in heaven's bliss,
They madë mickle mirth.

Angels bright they sang that night
And saiden to that child:
"Blessed be thou, and so be she
That is both meek and mild."

Pray we now to that child
And to his mother dear
Grant them his blessing
That now maketh cheer.

GLAD AND BLITHE MIGHT YE BE

Glad and blithë might ye be,
All that ever I here now see,
 Alleluia!

King of Kingès, Lord of all,
Born he is in oxen's stall,
 Res miranda.

The angel of counsel, now born he is
Of a maid full clean y-wys,* *indeed*
 Sol de stella

The sun that ever shineth bright,
The star that ever giveth his light
 Semper clara.

Right as the star bringeth forth his beam,
So the maid her bairnë teme,* *child bore*
 Pari forma.

Neither the star for his beam,
Neither the maid for her bairn-teme
 Fit corrupta.

The cedar of Lebanon, that groweth so high,
Unto the hyssop is made ally,
 Valle nostra.

Goddès son, of heaven bright,
Unto a maid is he alight,
 Carne sumpta.

Isaiah said by prophesy,
The Synagogue hath it in memory,
Yet never they lynneth* maliciously *cease*
 Esse ceca.

THE CHERRY TREE CAROL

Joseph was an old man,
 An old man was he,
When he wedded Mary,
 In the land of Galilee.

Joseph and Mary walkèd
 Through an orchard good,
Where was cherries and berries
 So red as any blood.

Joseph and Mary walkèd
 Through an orchard green,
Where was berries and cherries
 As thick as might be seen.

O then bespokë Mary,
 So meek and so mild:
"Pluck me one cherry, Joseph,
 For I am with child."

O then bespokë Joseph,
 With words most unkind:
"Let him pluck thee a cherry,
 That brought thee with child."

O then bespoke the babe,
 Within his mother's womb:
"Bow down then the tallest tree,
 For my mother to have some."

Then bowèd down the highest tree
 Unto his mother's hand;
Then she crièd, "See, Joseph,
 I have cherries at command."

O then bespokë Joseph:
 "I have done Mary wrong;
But cheer up my dearest,
 And be not cast down."

Then Mary plucked a cherry
 As red as the blood,
Then Mary went home
 With her heavy load.

Then Mary took her babe,
 And sat him on her knee,
Saying, "My dear son, tell me
 What this world will be."

"O I shall be as dead, mother,
 As the stones in the wall;
O the stones in the streets, mother,
 Shall mourn for me all.

Upon Easter-day, Mother,
 My uprising shall be;
O the sun and the moon, mother,
 Shall both rise with me."

THE JOLLY SHEPHERD WAT

Refrain Can I not sing but "hoy"
When the jolly shepherd made so much joy?

The shepherd upon a hill he sat;
He had on him his tabard and his hat,
His tar-box, his pipe and his flagat;
His name was called Jolly, Jolly Wat,
 For he was a good herdsboy.
 With hoy!
 For in his pipe he made so much joy.

The shepherd upon a hill was laid;
His dog to his girdle was taid.
He had not slept but a little braid* *moment*
But *"Gloria in excelsis"* was to him said.
 With hoy!
 For in his pipe he made so much joy.

The shepherd on a hill he stood;
Round about him his sheep they yood;* *went*
He put his hand under his hood;
He saw a star as red as blood.
 With hoy!
 For in his pipe he made so much joy.

The shepherd said anon-right:
"I will go see yon ferly* sight, *marvellous*
Whereas the angel singeth on height,
And the star that shineth so bright."
 With hoy!
 For in his pipe he made so much joy.

"Now farewell Mall, and also Will;
For my love go ye all still
Until I come again you till;
And evermore, Will, ring well thy bell."

With hoy!
For in his pipe he made so much joy.

"Now must I go there Christ was born;
Farewell, I come again to-morn.
Dog, keep well my sheep from the corn,
And warn well 'Warrock'* when I blow my horn."
 With hoy!
For in his pipe he made so much joy.

bark made by a dog

When Wat to Bethlehem come was
He sweat; he had gone faster than a pace.
He found Jesu in a simple place
Between an ox and an ass.
 With hoy!
For in his pipe he made so much joy.

"Jesu, I offer to thee here my pipe,
My skirt, my tar-box, and my scrip;
Home to my fellows now will I skip,
And also look unto my sheep."
 With hoy!
For in his pipe he made so much joy.

"Now farewell, mine own herdsman Wat."
"Yea, for God, Lady, even so I hat.*
Lull well Jesu in thy lap,
And farewell, Joseph, with thy round cap."
 With hoy!
For in his pipe he made so much joy.

am called

"Now may I well both hop and sing
For I have been at Christès bearing.
Home to my fellows now will I fling.
Christ of heaven to his bliss us bring!"
 With hoy!
For in his pipe he made so much joy.

commencement of pagan Yule feasting, or in the charming lyrics celebrating the
ancient sexual rivalry of holly and ivy:

> Holly and ivy made a great party* *debate*
> Who should have the mastery
> In lands where they go?
>
> Then spake holly: "I am fresh and jolly;
> I shall have the mastery
> In lands where they go."
>
> Then spake ivy: "I am loud and proud,
> And I will have the mastery
> In lands where they go."
>
> Then spake holly, and set him down upon his knee:
> "I pray thee, gentle ivy, say me no villainy
> In lands where we go."

SHIVERING BABE

The vast medieval laity often saw in the faces of the holy infant and his mother
a vision of contemporary human suffering. The theme of suffering especially
predominates in the Nativity lullaby carols depicting a shivering child and weeping
Virgin, for linked to the commoner's natural joy at the Incarnation was real
sorrow at the remembrance of the Passion. An aura of morbidity surrounds the
Nativity lullabies, despite their tender praise of Virgin and child. The pathetic
tone was due largely to the religious lullaby's poetic models, the dialogues between
grieving Mary and crucified Christ in the Latin literature of the church and the
secular *ubi sunt* poems lamenting man's fleeting happiness on earth. Many lullaby
carols thus show the infant as a miniature Christ on the cross, shivering unclothed
in his mother's arms, his tiny cries foreshadowing his death throes at Golgotha.

The most moving of these lullaby carols reflect the common medieval belief
that life was a cycle of joy and disaster and that Christ was a frail mortal destined
at the cradle for the tomb. The acute physical torments suffered by Christ as a
babe struck a familiar chord in the medieval imagination, for those torments were
depicted everywhere in late medieval portraits of Christ as a man. Passion plays,
dramatic cycles on Christ's life and death, were enacted in towns throughout
Europe. The liturgy itself centered around the eucharist and Passion. The popular

crucifixion studies in medieval art were graphic pictorial records of Christ's agonies on the cross. The influence of the Passion spills over into many medieval Nativity paintings, where Christ's swaddling bands resemble a winding cloth, his manger bears a striking resemblance to a coffin, and the Virgin appears in the sad pose of the pietà.

One particularly touching lullaby carol vividly underscores the humanity of both mother and son. Mary looks sadly on the quaking, freezing limbs of her firstborn and enumerates in vivid detail her little son's woes: the tiny, shivering body, the forlorn nakedness, the rude bed. Her catalogue of miseries is a direct imitation of the passage in the Good Friday liturgy in which the five wounds of Christ are enumerated in loving if clinical detail for the passerby. By accepting Mary's invitation to gaze on the child's poverty and distress, we too grieve with his mother over his eventual fate on the cross. Through Mary's song, the dogma of the Word made flesh is made palpably real by our reliving the same anguish as Christ in his assumption of infant form:

> Child, it is a weeping dale that thou art comen in,
> Thy poor clutes* it proven well, thy bed made in the bin; *rags*
> Cold and hunger thou must suffer as you were gotten in sin,
> And after die-yen on the tree for love of all man-ken.
>> Lullay, lullay, little child, no wonder though thou care
>> Thou art comen among them that thy death sulen yare.* *shall ransom*

The carol also shows the limited, though heartbreakingly human, judgment of Mary, who foresees only her great maternal grief when Jesus dies, not the transcendent joy at his resurrection. This is not the regal, splendid Virgin, untouched by mortal passions, of the courtly romance Marian carols. This Mary agonizes over her son's fate and begs him to grant her a quick death to follow his, for she cannot bear more pain:

> Since it most needs that thou be dead
> To saven man from the qued,* *devil*
>> Thy sweetë will be do.
> But let me not dwellen here too long;
> After thy death me underfong* *take, receive*
>> To ben forevermo. Amen.

LER TO LOVEN AS I LOVE THEE

Ler* to loven as I love thee; *learn*
On all my limbs thou might y-see
 How sore they quaken for cold;
For thee I suffer mickle* woe. *much*
Love me, sweet, and no mo* — *more*
 To thee I take and hold.

Jesu, sweetë sonë dear,
In poorful bed thou liest now here,
 And that me grieveth sore;
For thy cradle is as a bier
Ox and Asses ben thy fere* — *companions*
 Weepen may I therefore.

Jesu, sweetë, be not wroth,
I have neither clut* nor cloth *clout, rag*
 Thee in for to fold;
I ne have but a clut of a lappe,* *fold of a garment*
Therefore lay thy feet to my pap,
 And keep thee from the cold.

Cold thee taketh, I may well see.
For love of man it must be
 Thee to suffren woe.
For bet it is thou suffer this
Than man for-berë heaven's bliss —
 Thou must him buyen thereto.

Since it must needs that thou be dead
To saven man from the qued,* *devil*
 Thy sweetë will be do.
But let me not dwellen here too long;
After thy death me underfong* *take, receive*
 To ben forevermo. Amen.

SHE SANG, DEAR SON, LULLAY

Refrain This yonder night I saw a sight, And ever among a maiden sung,
A star as bright as any day, "By by, lully, lullay."

This maiden hight* Mary, she was full mild, *named*
She kneeled before her own dear child,
 She lullyed, she lappyed,
 She rullyed, she wrappèd
 She weepèd withouten nay;
 She rullyed him, she dressed him,
 She lyssyd* him, she blessed him, *comforted*
 She sang, "Dear son, lullay."

She said, "Dear son, lie still and sleep.
What cause hast thou so sore to weep,
 With sighing, with sobbing,
 With crying and with screeching
 All this land day;
 And thus waking with sore weeping,
 With many salt tears dropping?
 Lie still, my son, I thee pray."

"Mother," he said, "for man I weep so sore
And for his love I shall be tore.
 With scourging, with threat'ning,
 With bobbing,* with beating, *mocking*
 Forsooth, mother I say;
 And on a cross full high hanging
 And to my heart full sore sticking
 A spear on Good Friday."

This maiden answered with heavy cheer,
"Shalt thou thus suffer, my sweet son dear?
 Now I mourn, now I muse,
 I all gladness refuse;
 I, ever from this day.
 My dear son, I thee pray,
 This pain thou put away,
 And if it possible be may."

AS I LAY UPON A NIGHT

Refrain Lullay, lullay, la lullay,
My dear mother, lullay.

As I lay upon a night
Alone in my longing,
Me thought I saw a wonder sight,
A maiden child rocking.

The maiden would withouten song
Her child asleep bring;
The child thought she did him wrong,
And bade his mother sing.

"Sing now, mother," said that child,
"What me shall befall
Hereafter when I come to eld* — *old age*
So do mothers all.

Ich a* mother truly, *Every*
That can her cradle keep
Is wont to lullen lovely
And sing her child asleep.

Sweet mother, fair and free,
Since that it is so,
I pray thee that thou lull me
And sing somewhat thereto."

"Sweet son," said she,
"Whereof shall I sing?
Wist* I never yet more of thee *Knew*
But Gabriel's greeting.

He greeted me goodly on his knee
And said, 'Hail! Mary,
Full of grace, God is with thee,
Bearen thou shalt Messye.'

I wondered mickle* in my thought, *much*
For man would I right none.
'Mary,' he said, 'dread thee nought;
Let God of heaven alone.

The Holy Ghost shall do all this.'
He said withouten wone* *delay*
That I should bearen mannès bliss,
Thee, my sweetë son.

He said, 'Thou shalt bearen a king
In King Davidès see,
In all Jacob's wonynge* *dwelling place*
There king shall he be.'

He saidë that Elizabeth,
That barren was before,
A child conceived hath —
'To me leve* thou the more.' *believe*

I answered blethely,* *gladly*
For his word me paiyede,* *pleased*
'Lo! God's servant here am I!
Be it as thou me said.'

There, as he said, I thee bare
On midwinter night,
In maidenhood withouten care,
By grace of God almight.

The shepherds that watchèd in the wolde* *pasture*
Hearden a wonder mirth
Of angels there, as they told,
In time of thy birth.

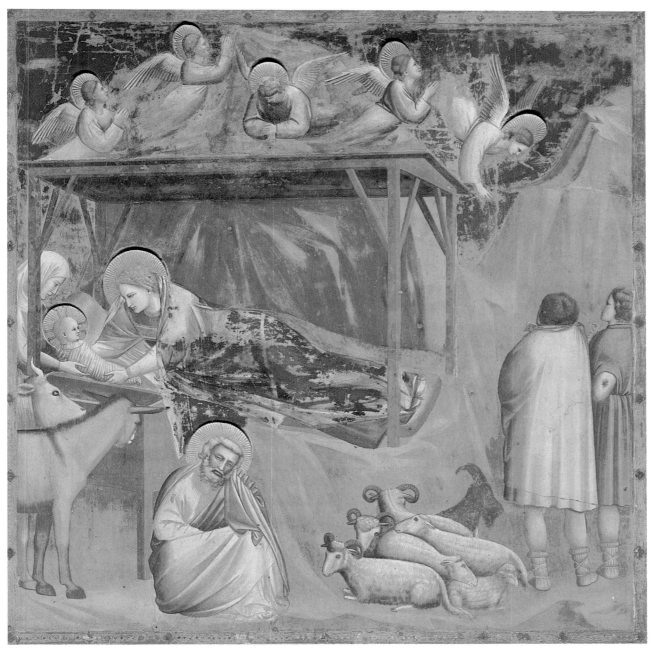

Plate 3. *Giotto,* Nativity *(fresco c. 1305/6)*
In Giotto's rather stark rendering, the manger resembles a bier, the mother assumes a pietàlike pose, and the swad- *dling clothes suggest winding bands — thus superimposing Christ's Passion on his Nativity. Scrovegni Chapel, Padua (Scala, New York/Florence)*

Sweetë sonë, sikirly* certainly
No more can I say;
And if I could, fain would I
To do all at thy pay."* liking

"Mother," said that sweetë thing,
"To sing I shall thee lere* teach
What me falleth to suffering
And do while I am here.

When the seven days ben done,
Right as Abraham wasce,
Cut shall I be with a stone
In a well tender place.

When the twelve days ben do,
By leading of a star
Three kingès me shall sekë tho* then
With gold, incense, and myrrh.

The fortieth day, to fill the law,
We shall to temple y-fere,* go
Then Simeon shall thee say a saw
That changen shall thy cheer.

When I am twelve year of eld,
Joseph and thou, mourning,
Shall me finden, mother mild,
In the temple teaching.

Till I be thirty at the least
I shall never from thee swerve,
But aye, mother, be at thine hest
Joseph and thee to serve.

When the thirty years be spent
I must begin to fill
Wherefore I am hither sent
Through my father's will.

John Baptist of merit most
Shall baptize me by name;
Then my Father and the Holy Ghost
Shall witness what I am.

I shall be tempted of Satan
That fawen is to fond,* eager is to tempt
The same wise that was Adam,
But I shall better withstand.

Disciples I shall gather
And send them for to preach,
The lawès of my father,
In all this world to teach.

I shall be so simple
And to men so cunning
That most party of the people
Shall willen make me king."

"Sweetë sonnë," then said she,
"No sorrow should me dere,* harm
Might I yet that day see
A king that thou were."

"Do way, mother," saidë that sweet,
"Therefore came I nought,
But for to be poor and bales bete,* miseries relieve
That man was innë brought.

Therefore when two and thirty year
ben done
And a little more,
Mother, thou shalt make mickle moan
And see me die-yë sore.

The sharpë sword of Simeon
Piercë shall thine heart,
For my care of mickle won* great quantity
Sorë thee shall smart.

Shamefully for I shall die,
Hangèd on the rood,
For man's ransom shall I pay
Mine own heartë blood."

"Alas! son," said that maid,
"Since that it is so,
Whereto shall I bide that day
To bearen thee to this woe?"

"Mother," he said, "Take it light,
For liven I shall again,
And in thy kind, through my might,
For else I wrought in vain.

To my father I shall wend
In mine manhood to heaven;
The Holy Ghost I shall thee send
With his sondès* seven. *gifts*

I shall thee taken, when time is,
To me at the last,
To be with me, mother, in bliss —
All this then have I cast.* *arranged*

All this world demen* I shall, *judge*
At the dom rising,* *judgment at the*
Sweet mother, herë is all *resurrection*
That I will now sing."

Certainly, this sight I say,
This song I heardë sing,
As I lay this Yules-day
Alone in my longing.

27

THE BEAUTIFUL MADONNA

Commoner and courtier were devoted, however, to a more idealized portrait of the Virgin and Christ. The Nativity was frequently depicted in European art as a luminous, regal domestic scene, far removed from suffering and death, especially by Flemish artists such as Hans Memling, the brothers Van Eyck, and Robert Campin, otherwise known as the Master of Flémalle. This idealized view of the Nativity also found its way into the carols, many of which drew upon the conventions of courtly love in portraying the Nativity as a romantic idyll for mother and son. At the center of this fanciful encounter was Mary herself, the richly garbed "Beautiful Madonna" of Franco-Flemish painting, fashioned also in the image of the famous beauties of courtly love lore such as Dante's Beatrice or Petrarch's Laura. Yet in her role as maid-mother, Mary was much more than the elusive heroine of the fabled *Roman de la Rose*. She was the beloved bride of the Song of Songs, the mystical mother church from which all faith sprung.

The lovely, artful folk lyric "I Sing of a Maiden" rewrites the biblical Annunciation story to accommodate Mary's role as romance heroine. As in the courtly romances, the poem is preoccupied with the seductive femininity of the lady. In order not to detract from her role as "leman," or lover, Mary's maternal aspect is presented symbolically through images of sexual fruitfulness. Christ's chivalrous approach to Mary's bower and the seminal April dew that "falleth on the spray" suggest the mystical infusion of divine essence into Mary's womb:

> He came all so stillë
> > Where his mother lay,
> As dew in Aprillë
> > That falleth on the spray.

The medieval Christian would not have been offended at the frank eroticism of the scene, for the prior example of the sensual Song of Songs was widely acknowledged as an allegory of Christ's love for the mother church.

Another well-known romance carol mingles both amorous and religious elements into a charming bucolic reenactment of the Nativity. The poem begins with a conventional medieval dream-vision. The poet wanders into a "herbere," or enclosed garden, filled with the music of turtledoves. There he spies a radiant maiden. Unaware of her secret admirer, the lady lifts up her voice in a love song to the mystical "Word made flesh":

> I passèd through a garden green,
> > I found a herbere* made full new — *arbor*
> A seemlier sight I have not seen,
> > On ilke* tree sang a turtle true — *every*

28

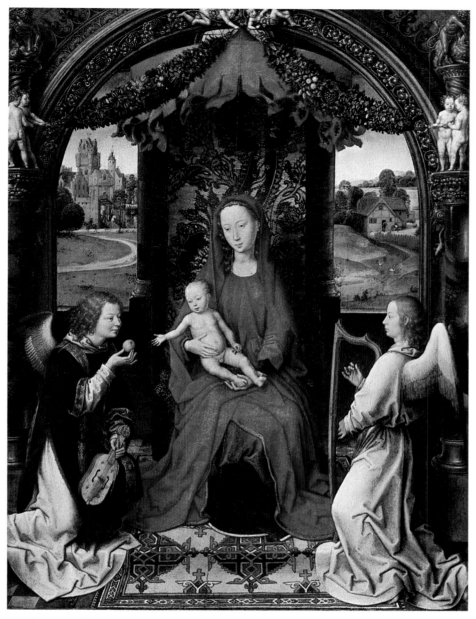

Plate 4. *Hans Memling,* Madonna on the Throne with Two Angels *(c. 1480 – 1485)*
Memling's depiction of the familiar "Beautiful Madonna" is rich with the detail that characterizes Flemish painting. The religious symbolism infuses the ordinary details with *sacramental meaning; we see the fruit of salvation, the blood-red berry in Jesus' hand, and the mother's tender caress of the heel that Satan would bruise. Uffizi Gallery, Florence (Scala, New York / Florence)*

Therein a maiden bright of hue,
 And ever she sang and never she ceased:
These were the notes that she can schew,
 Verbum caro factum est.

Other characters from the Nativity story join maid and dream lover in their rendezvous. Three shepherds enter singing the praises of a beautiful lady who has borne a divine child. "Three comely kings" follow suit, recounting another tale of this wonderful lady who clasps a god-child to her breast. In due time, the lady of the garden is revealed as the much-adored, mysterious Virgin mother. All the characters of the Franciscan Nativity tableau are therefore present. Yet that tableau is transformed into a pleasurable, amorous interlude without the actual presence of Christ to distract from Mary's disarming maidenliness. The cradle scene is further idealized in its third-hand description by the "royalest" king, who sees only the splendor and none of the sadness of mother and child:

I fared me further in that frith,* *forest*
 I met three comely kings with crowns;
I sped me forth to speak them with,
 And on my knees I kneelèd down.
The royalest of them to me con rone* *did address*
 And said, "We fared well at the feast;
From Bethlehem now are we bone* *bound*
 For *verbum caro factum est.*"

The medieval Christian knew that this poem was not a romantic trifle but a serious religious poem, for even the borrowed secular devices had been changed into symbols of the Incarnation. The "herbere" that the poet finds so enchanting is not that same bower of Eros found in the *Roman de la Rose*, but the *hortus conclusus*, the fruitful womb of Mary that encircles the material presence of Christ, the seed of eternal life. Even the bird who fills the bower with his music is not the nightingale, the well-known bird of love, but the turtledove of the Song of Songs, who proclaims the end of winter and a "new season of glad songs."

In poetry and in art, the cult of the "Beautiful Madonna" showed how deeply the continental ideal of courtly love had penetrated popular late medieval culture through the mediation of the *clerc*. Perhaps the laity's devotion to a steadfast maid-mother and her splendid child expressed their yearning for changeless beauty in an age when reality was often gruesome and when the goddess Fortuna's anger was quickly kindled.

I SING OF A MAIDEN

I sing of a maiden
　　That is makeless;*
King of all kingès
　　To her son she ches.*

*mateless,
but also matchless*

chose

He came all so stillë
　　Where his mother was,
As dew in Aprillë
　　That falleth on the grass.

He came all so stillë
　　To his mother's bower,
As dew in Aprillë
　　That falleth on the flower.

He came all so stillë
　　Where his mother lay,
As dew in Aprillë
　　That falleth on the spray.

Mother and maiden
　　Was never none but she;
Well may such a lady
　　Goddès mother be.

VERBUM CARO FACTUM EST

I passèd through a garden green,
 I found a herbere* made full new — *arbor*
A seemlier sight I have not seen,
 On ilke* tree sang a turtle true — *every*
 Therein a maiden bright of hue,
 And ever she sang and never she ceased:
 These were the notes that she can schew,
 Verbum caro factum est. * *the Word*
 is made flesh

I asked that maiden what she meant,
 She bade me bide and I should hear;
What she said I took good tent,* *heed*
 In her song had she voice full clear:
 She said, "A prince withouten peer
 Is born and laid between two beasts;
 Therefore I sing as ye may hear,
 Verbum caro factum est.

And throughout that frith* as I can wend, *forest*
 A blestfull song yet heard I mo:
And that was of three shepherds hend* *fair*
 "Gloria in excelsis deo."
 I would not they had faren me fro,* *gone from me*
 And after them full fast I pressed;
 Then told they me that they sang so
 For *verbum caro factum est.*

They said that song was this to say:
 "To God above be joy and bliss!
For peace in earth also we pray
 To all men that in goodness is.
 The maid that is withouten miss
 Has borne a child between two beasts;
 She is the cause thereof, iwis,* *indeed*
 That *verbum caro factum est.*"

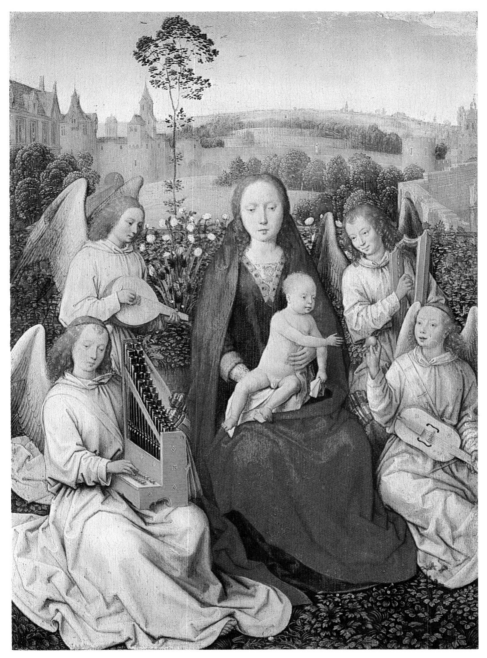

Plate 5. *Hans Memling, Mary in the Rose Garden (late fifteenth cent.)*
In this rendering of the "Beautiful Madonna," Memling
depicts the setting narrated in the poem "Verbum Caro Factum Est." Alte Pinakothek, Munich (Scala, New York/ Florence)

I fared me further in that frith,
 I met three comely kings with crowns;
I sped me forth to speak them with,
 And on my knees I kneelèd down.
 The royalest of them to me con rone* *did address*
 And said, "We fared well at the feast;
 From Bethlehem now are we bone* *bound*
 For *verbum caro factum est.*

For we saw God becomen in man's flesh
 That bote* has brought of all our bale,* *remedy; misery*
Away our sins for to wash;
 A maid him harbored in her hall,
 She succoured him soothely in her cell
 And held that hend* in her a-rest; *grace*
 For truly may she tell that tale
 That *verbum caro factum est.*"

Unto that princess will we pray,
 As she is both mother and maid,
She be our help as she well may
 To him that in her lap was laid;
 To serve him we be prest* and payd,* *eager; pleased*
 And thereto make we our behest,
 For I heard when she sang and said,
 "*Verbum caro factum est.*"

O MARY MILD, CALL HOME YOUR CHILD

Christ in the carols could be beautiful and remote or painfully human. Yet the many-sided, mortal Christ child of the Middle Ages could also be naughty and vengeful, showing qualities that were well-documented in local legend and art and verified in the Apocryphal books of Pseudo-Matthew and Pseudo-St. James. Although technically these legends centered on the childhood and adolescence of Christ, they came to rest side-by-side with the stories of the birth and infancy of Jesus. The Franciscans were particularly fond of these legends and wrote often of the malicious Jesus in sermons and ballads in order to warn small children against the dangers of arrogance or temper. In one such ballad, "The Bitter Withy," Christ is given a decidedly less than godly demeanor. The poem draws upon an Apocryphal legend in which the young Jesus outsmarts his rude playmates, enjoying a rather cruel revenge. After he is taunted by highborn children for his lowly birth, Jesus drowns the naughty youngsters and is severely thrashed by his angry mother:

> And its upling corns, and downling corns,
> The mothers of them did whoop and call,
> "Oh Mary mild, call home your child,
> For ours are drownded all."
>
> Then Mary mild called home her child,
> And laid it across her knee,
> And with a rod of bitter withy
> She gave him thrashes three.

It was not shocking to the medieval child to hear from the parson's lips how Christ plotted revenge on snobbish playmates, or to hear of his drowning some small evildoer, or to learn that even Christ was not spared his mother's rod. Medieval Christians, young and old, seemed unruffled by what appears irreverent or sacrilegious to us now. To the medieval layfolk, poems like "The Bitter Withy" were unquestionably didactic and no less delightful for their ethical content. They taught through Jesus' stern, childish system of justice the awful consequences of pride. Since human affairs and human nature were judged unpredictable, the layfolk could easily accept a Christ who was both victim and champion, and who, like any flawed mortal, could be spurred to anger as well as to forgiveness. The poems and legends showing Jesus as a naughty youngster are further evidence of the laity's familiarity with the Holy Family and of the freedom with which they accorded it all the frailties of humankind.

Out of the substance of their lives, medieval men and women shaped their paeans and laments to the infant Jesus in the crèche. In following centuries, the matter that the medieval common folk had created was formed and re-formed anew, and acquired novel, sophisticated shapes. Yet the tradition of English Nativity verse always verified an ethic that had served souls as faithful as St. Francis of Assisi, Wat the "jolly" shepherd, Henry Suso, and the honest guildsmen of Wakefield — the belief that "*mirabilem mysterium*, the son of God is man be-come," and that Christ was the people's own.

PRESERVERS OF TRADITION: DUNBAR AND ERASMUS

The first artful Renaissance Nativity poems were the products of two gifted Catholic clerics of Henry VII's time. Ironically, neither poet was a native-born Englishman. William Dunbar was a Scotsman whose English verses are flavored with the burr of his native dialect. Erasmus, the noted Dutch humanist and Anglophile, wrote in Latin. Neither were strangers to the Tudors, for Erasmus enjoyed the king's friendship while Dunbar was sufficiently moved by the prospect of a Tudor-Stuart alliance to compose "The Thistle and the Rose" in honor of the brilliant marriage of Margaret Tudor, Henry VII's eldest child, to James IV of Scotland. Their Nativity poems had enormous implications for English religious verse. Dunbar's "Rorate Celi de Super" is the first English Nativity poem to sound the distinctive, triumphal note that sets the refined Renaissance poet apart from the doctrinal medieval *clerc*. "De Casa Natalitia Jesu," Erasmus's Latin paean to the hut where Jesus was born, is the first Nativity poem since early Christian times to join classical motifs to biblical themes. Erasmus's approach was widely imitated in the next two centuries, especially by the most brilliant practitioner of the seventeenth-century Nativity poem, John Milton.

Dunbar and Erasmus were monks whose diverse talents made them anything but pious recluses. The repressive tendencies of the Franciscans irritated Dunbar. Erasmus rankled under the discipline of the Augustinians, refusing to don proper monastic garb and welcoming the long overseas assignments that kept him away for years at a time from his religious home at Steyn. Both were deeply respected by contemporaries for their vast learning, while both were involved in worldly matters, too: Dunbar as advisor to the Scottish king, Erasmus as diplomat, teacher, and counselor of monarchs and statesmen. The Nativity poems of these brilliant men share many common features. Both works are largely traditional, for they preserve the outlines of a decaying late medieval Catholic devotion to a humanized Savior while embodying radical religious and poetic insights for their day.

Dunbar uses elements from liturgy and Scripture to frame a delightfully personal and emotional attachment to the infant Jesus. The poem's first line recalls the Advent hymn of the same name by Fortunatus, a fifth-century hymnographer. The refrain *Pro nobis puer natus est* is a direct quotation from the Vulgate version of Isaiah 9:6, which translates into this familiar messianic prophecy:

> For unto us a child is born, unto us a son is given: and the government shall be upon his shoulder: and his name shall be called Wonderful, Counsellor, The mighty God, The everlasting Father, The Prince of Peace.

Despite the large role that both Catholic hymn and biblical traditions play in the poem, Dunbar advances a startling, new image of the infant Christ. He ignores the medieval Catholic view of the Nativity as an emblem of human suffering. Instead, Christ's descent to earth induces a joyful vernal renascence in which earthly and heavenly creatures arrange themselves in an ordered musical hierarchy. "Heaven, earth, sea, man, bird, beast" all have their proper place in that system of perfect harmony underlying the universe. Christ himself, in the guise of the Advent image of the dew, is shown as a glorious abstraction, a primordial natural force, before taking fleshly shape as a child in the Bethlehem crib:

> *Rorate celi desuper!*
> Heavens, distill your balmy showers,
> For now is risen the bright day star,
> From the rose Mary, flower of flowers:
> The clear Sun, whom no cloud devours,
> Surmounting Phoebus in the east,
> Is comen of his heavenly towers;
> *Et nobis Puer natus est.*

Dunbar could not have foreseen the great schisms in the English Catholic and Protestant churches in the next two centuries. Yet the ineffable, remote Christ of John Calvin and his followers gleams unmistakably in the countenance of Dunbar's divine child, "the clear Sun, whom no cloud devours."

Desiderius Erasmus is known primarily for his influential and voluminous prose works, yet like most cultivated men of his day, he often turned his hand to verse. Although written in Latin, his poem (rendered here in prose form) praising the humble birthsite of Christ was not a pedantic oddity to his contemporaries. It was composed when Latin was the lingua franca of learned men and reflected its author's consuming passion for enriching Christian doctrine with the wisdom of classical antiquity. It is very likely that the poem was known to the small circle of early Renaissance English humanists such as John Colet and Thomas More who became close friends of the poet during his several residencies in England.

In "De Casa Natalitia Jesu," the Nativity is so gilded with ornate diction and classical allusions that the tiny Christ becomes a magnificent hero. Christ displays the regal, warlike features of Pan, Apollo, and Hercules, mythological beings whom medieval and Renaissance people believed were pre-Christian Christ

RORATE CELI DESUPER

Rorate celi desuper!
Heavens, distill your balmy showers,
For now is risen the bright day star,
From the rose Mary, flower of flowers:
The clear Sun, whom no cloud devours,
Surmounting Phoebus in the east,
Is comen of his heavenly towers;
Et nobis Puer natus est.

Archangels, angels, and dominations,
Thrones, potentates, and martyrs sere,
And all ye heavenly operations,
Star, planet, firmament, and sphere,
Fire, earth, air, and water clear,
To him give loving, most and least,
That comes in to so meek manner;
Et nobis Puer natus est.

Sinners be glad, and penance do,
And thank your Maker heartfully;
For he that ye might not come to,
To you is comen full humbly,
Your soulès with his blood to buy,
And loose you of the fiend's arrest,
And only of his own mercy;
Pro nobis Puer natus est.

All clergy do to him incline,
And bow unto that bairn benign,
And do your observance divine
To him that is of kingès King;

Incense his altar, read and sing
In holy kirk, with mind digest,
Him honouring atour* all things, *over*
Qui nobis Puer natus est.

Celestial fowlès in the air
Sing with your notès upon height,
In firthès and in forests fair
Be mirthful now, at all your might,
For passèd is your dully night,
Aurora has the cloudès pierced,
The sun is risen with gladsome light,
Et nobis Puer natus est.

Now spring up, flowers, from the root,
Revert you upward naturally,
In honour of the blessed fruit
That rose up from the rose Mary;
Lay out your leavès lustily,
From death take life now at the least
In worship of that Prince worthy,
Qui nobis Puer natus est.

Sing, heaven imperial, most of height,
Regions of air make harmony;
All fish in flood and fowl of flight
Be mirthful and make melody:
All *Gloria in excelsis* cry,
Heaven, earth, sea, man, bird, and beast,
He that is crowned above the sky
Pro nobis Puer natus est.

WILLIAM DUNBAR

43

DE CASA NATALITIA JESU

Indeed, why do we follow after displays of ancient things? Hither, hither come running in crowds! This hut, standing dilapidated and bristling with country thatch, provides a new display, a sight such as our forebears in the ages of antiquity never witnessed, nor will our descendants ever witness.

Here, the one at whose thunder earth and sky quiver whimpers with soft wails. Here, as an infant, the all-great governor of the great globe suckles the breasts of a virgin. I would judge neither the august Palatine of Rome, nor the temples of Solomon (however laboriously erected), nor the golden palace of the Lydian tyrant more blessed than these stables.

Hail illustrious home, more blessed than heaven itself, and conscious of the sacred birth! Well might the Capital of the pretender Jove envy you, proud though it be with its stone-hewn gods. Well might Egypt envy this sacred cradle, which is destined to bring to an end her own vile prodigies.

Nor are you the less suitable for a god because you admit showers and East winds through your cracks, gaping on every side. Although you are in need of a counterpane and are incommodious with your stiff straw, you receive in his first flush the newborn child. Such a bed befitted Christ at his birth, as the one who has come expressly to unteach our fastidiousness and luxury, which engulf us in vileness.

Here no purple vestments glitter, here are no crowns of leaves, no torches flickering like thunderbolts, no costly banquet table. Nor does a lofty couch enfold the newborn child. In a rough manger lies the ragged child. Yet a divine robustness flashes forth; in his very crying he emits here and there his father's flames. The cattle perceive the presence of deity and, as much as they can, relieve the December chill with their warm breath. The shepherd sings some rustic but pious air on the same pipes on which he had earlier sung to his goats; ethereal choruses flutter about the cradle. Just as swarms of bees in the months of spring, as soon as they have driven forth some degenerate king bee, applaud their new ruler with favoring wings and exalt him in formation, so the emissaries of heaven cluster about their chief rejoicing, and marvel at him as he lies. Their faces gaze down at the manger as they adore him and sound the birthday hymn. The decent husband, meanwhile, prostrate on the ground and trembling, reveres his great foster child.

The young girl, in turn, a great part of this illustrious display, keeps her gaze fixed with downcast eyes, and at first hardly contains herself, a little virgin mother marvelling at both herself and her offspring, an offspring not the son of any husband. But as soon as motherly concern has expelled her astonishment, she snatches up this sweet pledge and now keeps him from crying by extending her breasts, now gently fondles him, cold in her warm lap, now presses him to her bosom, and now coaxes soft slumbers with her lisping murmur. By turns, you see the mother exult joyfully, charmingly, over her divine offspring, just as the child joys in his virgin mother. DESIDERIUS ERASMUS

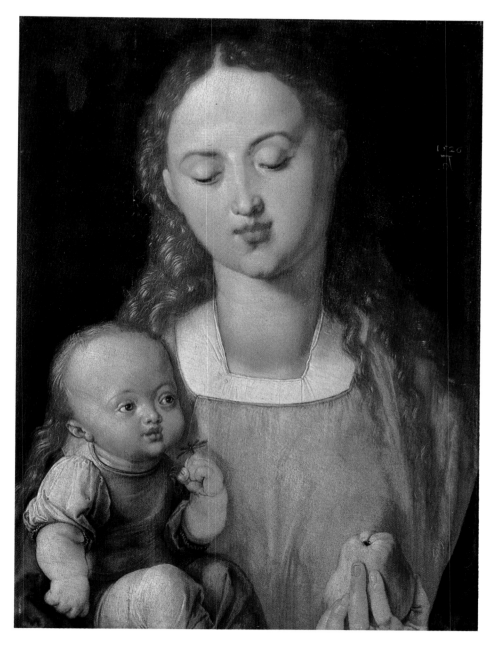

Plate 7. *Albrecht Dürer,* Madonna and Child *(1526)*
Dürer, a contemporary of Erasmus and his equal as a master of classical Renaissance humanism, portrays a quietly adoring Virgin much like that described in "De Casa Natalitia Jesu." Uffizi Gallery, Florence (Scala, New York / Florence)

figures. Skillfully, Erasmus fuses the classically heroic qualities of the infant with the weak, suffering features of the babe from the Passion-oriented Nativity lyrics of the Middle Ages. Christ is a tiny Jupiter, the one at whose thunderous birth earth and sky quiver; yet he whimpers with soft wails. He is *moderator maximus infans*, the all-great governor of the immense globe; yet he lies helplessly in the arms of his adoring mother. His small, inarticulate cries issue forth holy flame, impregnating the world with what Erasmus called the "philosophy of Christ," Jesus' divinely inspired, life-changing teachings.

THE WHEEL OF FORTUNE

> Little Jack Horner
> Sat in a corner
> Eating a Christmas pie.
> He put in his thumb
> And pulled out a plum,
> And said, "What a good boy am I!"

Few may know that this innocent rhyme pokes fun at a momentous episode that changed the course of English history — Henry VIII's destruction of the Catholic monasteries in the 1530's. There is more to this bit of childish doggerel than smug little Jack's sweet tooth. What lies between the lines is a rags-to-riches climb of a real young adventurer, Thomas "Jack" Horner. Legend says that Jack went to King Henry VIII bearing a Christmas gift-bribe from the abbot of Glastonbury, who feared that Henry would dip too deeply into the church till. As avaricious as his monarch and as shrewd as his master, young Jack peeked into the gift, saw that it contained the deeds to twelve rich estates, and pulled out a real "plum" — the fine manor of Mells, which he pocketed for himself. The ambitious steward soon had good reason to congratulate himself. The poor abbot was hanged, drawn, and quartered in the barbarous fashion of the day for the crime of withholding church treasure from the crown, while Jack found favor with the king. In another bizarre twist of fate, Jack sat on the jury that unanimously convicted his master; then he retired to Mells to enjoy the fruits of his crime.

Greedy Henry, the wily abbot, and clever Jack were real men trying valiantly to survive and prosper in a vigorous, hurly-burly era governed by savagely capricious fates. This was a time when opportunists like Jack Horner could win prestige by bending with each new wind of opinion or patronage that blew their

way, whether popish breeze or Protestant gale. The risks were enormous. Success brought one to dizzying heights, but falls were fatal and all too frequent.

It was the prerogative of Henry VII's willful descendants to make men or break them. If the universe was ordered and hierarchical, like an immense golden chain let down from the heavens, then princes were demigods, ranking far above other creatures on earth and only slightly below angels. In reality, unruly mortal passions like anger or pride were quickly kindled in Tudor breasts. Absolute power plus human failings made a dangerous combination. A burst of a monarch's temper could mean a subject's quick death or an upheaval in the state. The rocky careers of powerful courtiers and prelates in the reigns of Henry VII's quixotic brood easily show the dangers of staking one's future on the favors of a Tudor prince.

There was Cardinal Wolsey, butcher's son, who became Henry VIII's wealthiest and most powerful advisor, but who fell headlong into ruin for choosing his pope over his king. At a time when soldiers made verses, poets, too, were blasted by the heat of a monarch's rage. Even as he lay dying, Henry VIII would not set aside his hatred for the powerful Howard clan. Shakily but firmly, he affixed the royal seal to the death warrant of its most powerful and brilliant heir, Henry Howard, Earl of Surrey, and sent into oblivion the finest love poet of his court.

The number of illustrious men and women helped untimely to their graves grew as Tudor supplanted Tudor and Protestantism vied with Catholicism for national supremacy. No wonder that a popular sixteenth-century best-seller was *Mirror for Magistrates*, a gossipy chronicle of the tragic careers of former "worthies" like Jane Shore, once a king's mistress, later a common whore. These parables of the mighty being humbled confirmed what the average Englishman beheld daily: the quick disappearance of fame; the danger of firm religious scruples; the clash of headstrong princes with defiant subjects. Leave it to poets and divines like William Dunbar to sing of "heaven, earth, sea, man, bird, beast," nature's grand harmonious design. Commoners saw and recognized a disorderly world caught in the thick of social and religious change. Most hailed that change as a liberation from an autocratic, foreign-controlled religious past and as the restoration of a true, promised kingdom. Many privately feared that the fickle Roman goddess Fortuna still held her people captive on her ancient, ever-spinning wheel.

BLUFF KING HAL

Erasmus found unmistakable traces of greatness in the face of the future Henry VIII when the prince was no more than nine. "Here is my Apollo, the father of the

age of gold," gushed the young Dutch scholar who knew how to flatter his royal friends. As a youth, "bluff King Hal" proved every inch the Apollo. His winsome Christmas carols and high-spirited dancing captivated the ladies of his gay young court. He even charmed Pope Leo X with a book denouncing the "venomous serpent," Martin Luther. Yet in his middle age, Henry VIII became a vicious spoiler, feuding with the great Catholic powers, warring with his barren first wife, Catherine of Aragon, who refused to be quietly set aside, and defying a stubborn new pope, Clement VII, who would not sanction Henry's liaison with the ambitious Anne Boleyn while Catherine still lived. In his zeal for a male heir, Henry embarked on a desperate campaign to divorce Catherine, a loyal daughter of the Catholic Church. If the pope would not permit a second marriage to Anne, then he, Henry VIII of England, God's anointed, would "reform" the church by declaring the pope's power over the English sovereign null. It wasn't sufficient for Henry to torture and burn Catherine's priest-confessors, the very monks who had witnessed his first marriage vows. He confiscated monasteries and cathedrals, the centers of Catholic influence, and channeled their monies into his coffers. The chapel of the London Charterhouse became an immense tool shed. Maison Dieu in Dover was used to house chickens and vegetables. Nuns and monks were turned out of convent and cloister. Craftsmen, whose markets evaporated when churches and shrines were plundered, begged openly on the streets. Learned, pious statesmen like John Fisher and Thomas More, who had once walked with the young king in the first golden years of his reign, now marched to tower and scaffold. A foreigner during this bleak period wrote home grimly: "In England, death has snatched everyone of worth away, or fear has shrank them up."

Henry VIII died convinced that his ecclesiastical revolution was worth his people's pain. He had proven himself *defensor fidei*, loyal defender of the "true" Catholic faith in England. He had given the English a sense of their own nationhood. Yet as husband and father he was an abject failure. History has given him the reputation of a Renaissance Bluebeard, and his bizarre, brutal marital record does not dispute his claim to the title. One does not easily forget the middle-aged Henry decked in saffron yellow satin, cutting capers at the news of Catherine's death. He was capricious and cruel to his children, too; to ensure the succession through Edward, his only son, he publicly proclaimed his two daughters bastards, although he had once doted upon Mary, his eldest child. His reign, moreover, sent a cruel fissure into the rock of religious life that in the next century would split brother from brother, father from son, and finally people from prince.

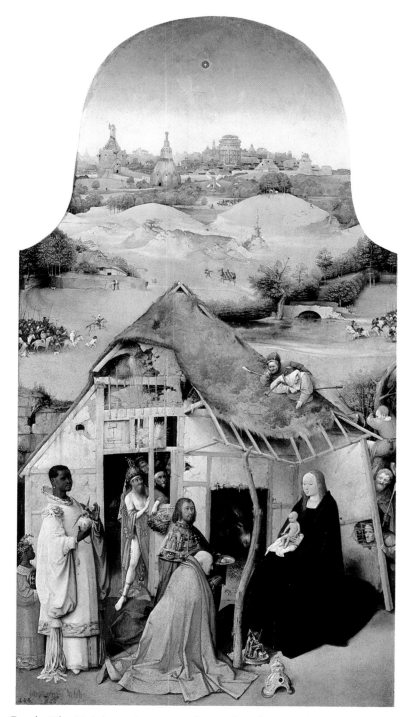

Plate 8. *Hieronymous Bosch,* The Epiphany *(center panel of tryptych:* Adoration of the Magi, *c. 1510)*
The social, political, and religious upheaval of his time is *reflected in Bosch's Nativity scene, in which warring armies occupy the plain behind the stable. Prado, Madrid (Scala, New York/Florence)*

GREEN GROWETH THE HOLLY

The people of Tudor England could not abstain from carol singing even while Protestant hostilities to Christmas festivities grew stronger in the reigns of Henry and his Protestant heirs, Edward and Elizabeth. On the continent, the reformers were purging the Catholic "Christ-mass" of its pomp and superstition and imposing a more severe and spiritual seasonal celebration upon their followers. By contrast, Tudor England, with its eclectic brand of Protestantism, had a freer hand in keeping a Christmas that was "merry" in the ancient Anglo-Saxon spirit of Yule.

With the English Reformation just around the corner, the carol made a last joyous stand in young Henry VIII's stylish, pleasure-loving court. Henry himself spent lavishly on Yule-tide entertainments. The Tudor historian Edward Hall recalls a Christmas early in Henry's reign at Greenwich,

> where was such abundance of viands served to all comers of any honest behaviour, as hath been few times seen. . . . In came the king with five others, apparelled in coats, the one half of russet satin, the other half of rich cloth of gold; on their heads caps of russet satin embroidered with works of fine gold bullion.

It was even common for Catholic prelates of Henry's time to hold large, costly Christmas feasts in their huge dining halls, where malmsey and other wines, minstrels, and carol singers were regular elements of a sumptuous holiday dinner that included the traditional roast ox. The high point of the evening's festivities for laity, courtiers, and clerics was the after-dinner custom of singing carols "in remembraunce of Christmasse," with one leader singing the verses and the huge company joining in at the refrain.

The distinguished scholar of carols Richard Leighton Greene suggests that all carols, secular and pious, were principally social entertainments for people of all classes. But in the carols of Henry VIII's early reigning years, the element of mirth seems particularly strong and sustained. In fact, the Henrician carol appears to be only a distant cousin of the sober religious lyrics of the previous two centuries. The Christmas carols of Henry's time are less concerned with the niceties of dogma than were their medieval progenitors. They are light-hearted, frivolous pieces by poet-musicians, like the youthful king himself, who celebrated both sacred and profane muses and who interwove commonplace Nativity formulae with the colorful Yule customs that were practiced far into Elizabeth's day. The predominating spirit is "Hay, ay, hay, ay, / Make we merry as we may," as in

50

HAY, AY, HAY, AY

Refrain Hay, ay, hay, ay,
 Make we merry as we may.

Now is Yule comen with gentle cheer;
Of mirth and gomyn* he has no peer; *games, merriment*
In every land where he comes near
 Is mirth and gomyn, I dare well say.

Now is comen a messenger
Of yourë Lordë, Sir New Year,
Biddès us all be merry here
 And make as merry as we may.

Therefore every man that is here
Sing a carol in his manner;
If he can not we shall him lere,* *teach*
 So that we be merry alway.

Whosoever makes heavy cheer,
Were he never to me dear;
In a ditch I would he were,
 To dry his clothes till it were day.

Mend the fire, and make good cheer!
Fill the cup, Sir Bottler!
Let every man drink to his fere!* *companion*
 This ends my carol with care away.

MAKE WE MERRY

Refrain Make we merry, both more and less,
For now is the time of Christemas.

Let no man come into this hall,
Nor groom, nor page, nor yet marshall,
But that some sport he bring withal,
 For now is the time of Christemas.

If that he say he cannot sing,
Some other sport then let him bring,
That it may please at this feasting,
 For now is the time of Christemas.

If he say he naught can do,
Then for my love ask him no mo,
But to the stocks then let him go,
 For now is the time of Christemas.

WASSAIL, WASSAIL, WASSAIL, SING WE

Refrain Wassail, wassail, wassail, sing we
In worship of Christ's nativity.

Now joy be to the Trinity,
 Father, Son, and Holy Ghost,
That one God is in Trinity,
 Father of Heaven, of mighties most.

And joy to the virgin pure
 That ever kept her undefiled,
Grounded in grace, in heart full sure.
 And bare a child as maiden mild.

Bethlehem and the star so shene,* *shining*
 That shone three Kingès for to guide,

Bear witness of this maiden clean;
 The Kingès three offered that tide,

And shepherds heard, as written is,
 The joyful song that there was sung:
"Gloria in excelsis!"
 With angels' voice it was out rung.

Now joy be to the blessedful child,
 And joy be to his mother dear;
Joy we all of that maiden mild,
 And joy have they that make good cheer.

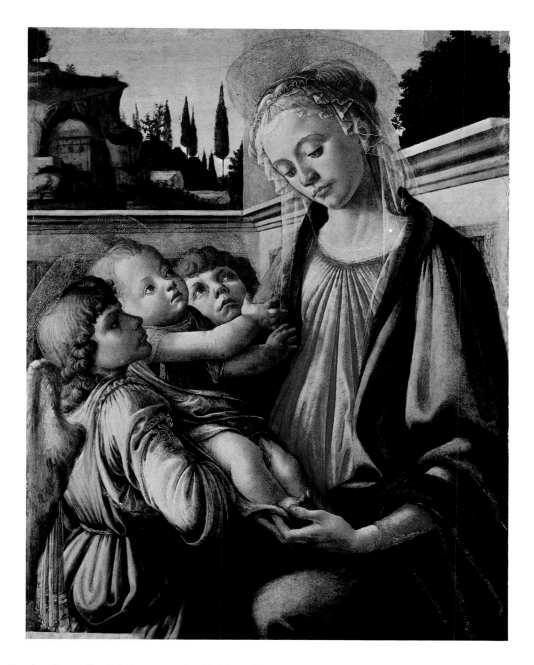

Plate 10. *Sandro Botticelli*, Madonna with Child and Angels *(c. 1468/9)*
Botticelli's work represents the lyrical, courtly, and stylized strain of Renaissance art compared to the more vibrant, *robust work of Raphael. The distinction is much like that between the Nativity poetry of Elizabeth's court and that of Henry's court. Capodimonte Museum, Naples (Scala, New York/Florence)*

The court musician William Byrd set the ornate Elizabethan Christmas lyric of Francis Kinwelmersh, mistakenly entitled "A *Carol* for Christmas Day," as a four-part madrigal. Byrd also composed Christmas lyrics of his own for his collections of madrigal verse, such as his sophisticated imitation of a medieval lullaby carol, "Lulla, La, Lulla Lulla Lullaby." Byrd's lullaby has all the right elements — Virgin's lament, the shadow of the child's death, the evil Herod, the shepherds and magi — yet its "medieval" piety has become quaintly anachronistic:

> Lulla la, lulla lulla lullaby.
> My sweet little baby, what meanest thou to cry?
> Be still, my blessed babe, though cause thou hast to mourn,
> Whose blood most innocent to shed the cruel king hath sworn,
> And lo, alas, behold, what slaughter he doth make,
> Shedding the blood of infants all, sweet Saviour, for thy sake.
> A King is born, they say, which King this king would kill.
> O woe, and woeful heavy day, when wretches have their will.

Elizabeth's patronage of musicians like Byrd and Thomas Tallis rescued the native English song tradition from Puritan destruction. The Puritans favored group singing of the metrical psalms, deplored the Henrician carol as frivolous, and rejected the Elizabethan madrigals, "ayres," and "ballets" as too fancy. In the seventeenth century, the Puritans would win their fight against musical Christmas frivolity. Cromwell would declare Christmas illegal, and the great flood of religious folk song begun in the late Middle Ages and revived briefly in Henry's and Elizabeth's courts would cease. But Christmas ballads and carols still circulated underground under the very noses of Cromwell's men and in small pockets of resistance, as at Oxford University, where students still sing the "Boar's Head Carol" every year at Christmas.

The most interesting, artful Elizabethan works on the Nativity are not among the carols, but may be found within a small, burgeoning strand of devotional verse developed slowly in the closing years of the century by learned clerics such as William Alabaster and Robert Southwell. The Nativity poems of these poets are worlds apart from the lively Christmas carols of Henry's and Elizabeth's courts. They are meant for reading, not singing. Their setting is the library, not the banquet hall. Their audience is the cultured man of letters, not the merrymaking throng, satiated with rich food and drink.

These new literary Nativity poems are ornate in diction and strong in feeling. We no longer hear in them the anonymous voice of the carol maker

SONNET 56

Incarnatio est Maximum Dei Donum

Like as the fountain of all light created,
Doth pour out streams of brightness undefined,
Through all the conduits of transparent kind,
That heaven and air are both illuminated,
And yet his light is not thereby abated:
So God's eternal bounty ever shined
The beams of being, moving, life, sense, mind,
And to all things himself communicated.
But see the violent diffusive pleasure
Of goodness, that left not till God had spent
Himself by giving us himself, his treasure,
In making man a God omnipotent.
How might this goodness draw our souls above,
Which drew down God with such attractive love!

WILLIAM ALABASTER

SONNET 62

Omni Propter Christum Facta

God and man, though in this amphitheatre
Are many works with beauty varnishèd,
Yet all for thee, by thee were polishèd,
And first intended by the world's creator;
Like as a picture of fair grace and stature
That with a margent is embroiderèd,
Wherein are thousand smaller fancies spread,
Thou art the picture, and the border nature.
Not that the world is ornament to thee,
But thou to it that deignst therewith to be;
Yet as a step it doth thy greatness show
And workman's power, whose art so high could rise
In thee, and in thy border fall so low,
No border unto thee, but to our eyes.

WILLIAM ALABASTER

SONNET 66

Omnia Propter Christum Facta

By what glass of resemblance may we see
How God and man, two natures, meet in one?
Or is it like unto that union
Whereby the soul and body do agree?
Or like as when a graft of foreign tree
Grows in some other by incision?
Or like as when about one diamond
Two rings are fasten'd which one jewel be?
Or as when one same party is both man
And is together a musician?
Or like as iron unbodied
With interfused fire into one mould?
No, no, for these resemblances are dead.
How are they then conjoinèd? As God would.

WILLIAM ALABASTER

Plate 11. *Andrea del Sarto,* Madonna and Child *(early sixteenth cent.)*
Of all the painters of the High Renaissance, the work of Andrea del Sarto is most akin to the devotional mode in poetry. Note his disregard for setting or background; like an Ignatian devotion, the painting focuses strictly on the figures of the Virgin and the Christ child and forces us to contemplate them alone. Prado, Madrid (Scala, New York/ Florence)

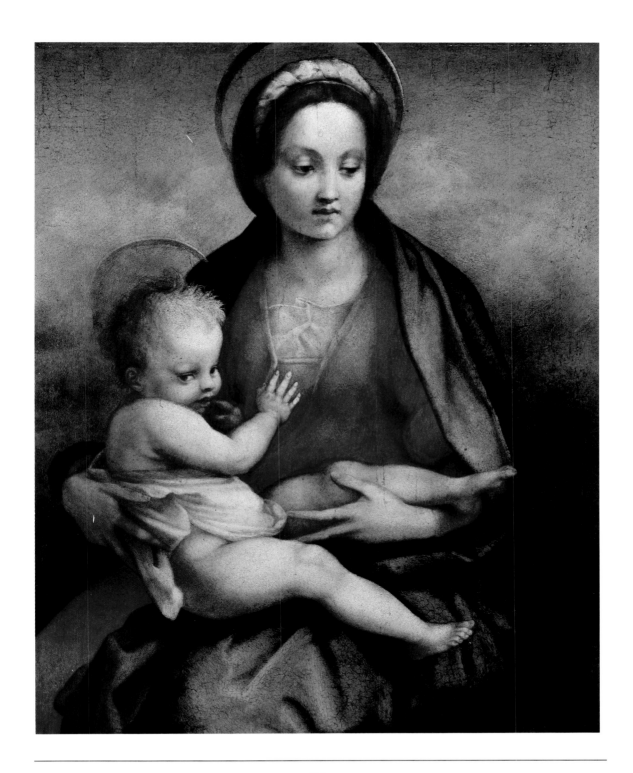

SONNET 74

Jesus is born. Peace, such high words forbear,
Which only angel's mouth deserves to unfold.
Then let them speak these mysteries enrolled.
Ay me, they must be sung of that sweet choir.
Then let mine ears that blessed carol hear.
No, only holy shepherds be so bold,
With joy then let them hear this uncontrolled.
Nor so, for holy shepherds hear with fear.
Ay me, that am unworthy him to name,
Yet none so worthy to be named as he,
Ay me, unworthy for to hear the same,
Yet nothing so deserveth heard to be.
What then? Compare both these, his worth, my scorn;
His far weigheth down: Jesus is born.

WILLIAM ALABASTER

III *The Dreaded Infant*

THE SEVENTEENTH CENTURY

OUR DAINTY AGE

And since our Dainty age
Cannot indure reproof,
Make not thyself a Page
To that strumpet the Stage,
But sing high and aloof,
Safe from the wolf's black jaw and the dull Ass's hoof.

IN "An Ode to Himself" (1640), the poet and playwright Ben Jonson saw deep into the tragic heart of the war-torn seventeenth century, the era of the finest Nativity poems in the English tongue. Years before a disenchanted people had struck off their sovereign's head and replaced his rule with a Puritan theocracy, Jonson ironically noted a disturbing "daintiness" among the theatergoing audience. The seventeenth-century public disdained the gentle sermonizing, the honest "reproof" of Elizabethan dramatists. It was blood and guts they lusted after. Audiences cheered as the clash of antagonists led onstage to the inevitable bloody conclusion. In real life, this "dainty" drama was played out by the two great antagonists, crown and Parliament, whose quarrels shaped the violent first half of the seventeenth century. The battle was joined in many quarters, not only between "Cavalier" and "Roundhead," Anglican and Catholic, Anglican and Puritan, aristocracy and rising middle class. Dissension invaded cultural preserves too, for science battled religion, reason undermined authority, the New Learning grappled with the Old.

Jonson's stoic advice to himself as writer was to avoid the contentious "wolves" and "asses" of the world by retreating to a "high and aloof" position of amused detachment. Nevertheless, many devotional poets challenged rather than ignored the "dainty" public. Poets like Donne, Herbert, Crashaw, Milton, and Vaughan rejected Jonson's Olympian poetic stance and sought to capture in verse the great political and religious forces that were sweeping through their

lives. The scriptural theme of Christ's Nativity weaves a colorful rich thread through the ingenious, often troubled devotional poems of Donne and his "metaphysical" heirs as well as through the heroic verses of Milton.

These seventeenth-century Nativity poems can be seen as virtual historical documents chronicling the revolutionary tenor of the times. Even as he puts on the mask of detached observer, Jonson, too, cannot hide a deeply felt political and religious credo. Thus, early in the century, he makes the Nativity a symbol for stable government under the Stuart kings in his complimentary epigram to the young Queen Henrietta Maria at her lying-in. Richard Crashaw, confidant of an older, embittered Henrietta Maria in exile, celebrates in his Nativity "hymn" a neomedieval devotion to the Christ child popular among mystics of the Counter-Reformation. The brilliant "Nativity Ode" of the young John Milton is a manifesto of his militant Puritanism and a testing ground for his later, greater work in *Paradise Lost*. To the disillusioned Royalist Henry Vaughan, the Nativity is an ambivalent symbol for the arbitrary, elusive relationship between God and sinful man. Throughout the rich variety of seventeenth-century Nativity verse there runs a tide of uncertainty made deep by the swift and shifting currents of history.

THE SEEDS OF REVOLUTION

For all the upheaval of their reigns, the Tudors projected a proud image of national solidarity. They were succeeded by the Stuarts, descendants of Mary of Scotland, who were as incapable of kindling the love of their subjects as that proud, unhappy queen. James I of England, Mary's son, was hardly a suitable replacement for the brilliant Elizabeth. What James's new subjects saw when he took the throne in 1603 was an untidy, nervous, heavyset king who doted on his homosexual favorites and who "was more tender over the life of a stag than a man."

In all fairness, James was an able, intelligent ruler whose unhappy childhood had armed him with caution and good sense. Yet he was hounded by a bad public image, by the ruinous follies of his favorites, and by revolutionary historical forces beyond his control. Henry VI of France sardonically pronounced him the "wisest fool in Christendom," and ironically, the words of one of his great detractors have survived as history's frankest assessment of James. His wisdom endures in the magnificent "Authorized Version," or King James Bible, of 1611, a massive project of scriptural translation sponsored solely by the king, which pooled scholarly and literary talents from all the warring sects of the time.

Great was James's folly, too: when English Puritans presented him with a "Millenary Petition" early in his reign, calling for church reforms and increased toleration, memories of his loveless unbringing under the stern Calvinist lords of Scotland triggered a royal tantrum. Angrily, he vowed to "harry [the Puritans] out of this land." What James shrewdly smelled was a move to curb the monarchy. "No bishop, no king," was his famous retort. In making enemies of the Puritans, James lost a valuable opportunity for bridging the deep divisions in the English church. Even worse, James deepened the rift by throwing his support to the conservative, anti-Puritan wing of the Anglican church under Bishop William Laud, thus hastening England's drive toward civil war.

As James's recent biographer Antonia Fraser suggests, perhaps no monarch could have pacified a people who had had their fill of absolute monarchs and who were "in the mood of horses held too long in the stable." As the crown's debts mounted, so too did popular outcry against the remote, self-indulgent king and his scandal-ridden court. Once, James's pet beagle brought home this desperate piece of revolutionary doggerel around his neck:

> Then let him hear, good God, the sounds
> And cries of men, as well as hounds.

Out of the nation's disappointment with James, there emerged the legend of "Good Queen Bess," which waxed ever greener and brighter with the years and plagued the reigns of all the Stuarts. The poet Michael Drayton lived under both Elizabeth and James, yet continued to treasure the memory of Tudor prosperity. His popular national epic, *Poly-Olbion* (1611), embodies an old-fashioned Tudor-style patriotism that still lingered in James's time and that looked for its heroes on native soil:

> My native country, then, which so brave spirits hast bred,
> If there be virtue yet remaining in thy earth,
> Or any good of thine thou breath'dst into my birth,
> Accept it as thine own whilst now I sing of thee.

Poly-Olbion's optimism was already a relic from another age. Even that giant Shakespeare had felt the slowing of his country's pulse and had turned from writing spirited histories and comedies to the somber, world-weary tragedies of his middle age. In 1611, the year of *Poly-Olbion*'s publication, the forty-seven-year-old Shakespeare retired altogether. 1611 also saw the creation of another poem which was far more representative of the dark mood of James's reign than

Drayton's idealistic epic. John Donne's "The Anatomie of the World" bemoaned an England whirling in a vortex of decaying beliefs. The grand Elizabethan theme of harmony had been usurped by the grand Jacobean themes of confusion, corruption, and lonely individualism:

> 'Tis all in pieces, all coherence gone,
> All just supply, and all relation;
> Prince, subject, father, son are things forgot,
> For every man alone thinks he hath got
> To be a phoenix, and that then can be
> None of that kind of which he is, but he.

THE BEAUTY OF HOLINESS

In times of great stress, the devotional poet sometimes finds and sounds the sublimest key. The theater shriveled under the rigid censorship of James I and his son Charles I. Yet Nativity poems flourished in the first half of the seventeenth century along with the larger flowering of devotional verse as a whole. Under the watchful eyes of Archbishop Laud, the Anglican church was busy promoting "the beauty of holiness": many of the rituals of Catholicism were incorporated into Anglican worship as Laud vowed, with the royal consent, to bring the sacrament-hating non-Conformists literally to their knees before the church altar. The beautiful, formal Nativity lyrics of the Anglican poets John Donne and George Herbert are cast in the Laudian mold. They continue the ancient Catholic tradition of liturgical church verse that predominated throughout the Middle Ages and sixteenth century in England. These poems are artful, original works, which nevertheless show dangerous cracks in the Anglican church structure. Religious conflict is mirrored to a remarkable and surprising degree in the poems of even these devoted Anglicans, John Donne, the celebrated preacher of St. Paul's, and George Herbert, the shy country parson of Bemerton. To Donne and Herbert, the "beauty of holiness" meant a fragile state of grace won with the aid of an embattled church tradition.

The Nativity offers both poets an opportunity for self-examination within traditional poetic forms, using ancient liturgical symbols. In Donne's "La Corona" (1607) and Herbert's "Christmas" (1633) the reader is a witness to the unfolding of a real-life drama. In Donne's case, this air of subjectivity is all the more striking in that "La Corona" is a throwback to medieval meditations on the life of Christ written long after the *vita Christi* had ceased to hold much meaning for the

Protestant English. Donne's "La Corona" is a sonnet sequence resembling a Catholic rosary meditation on the Virgin and child. Yet Donne's poem is not a mechanical exercise, for each sonnet shows the poet's own emotional response to a separate event in the life of Christ. Sonnet 3, on the "Nativity" of Christ, is a spontaneous dramatic monologue in which the poet mentally seizes on details of the gospel scene to make them real to his mind and heart. Donne steps into his poem by entering the Bethlehem setting. "Seest thou, my Soul," he says, charging himself with the fact of his pitiable worth, forcing himself to "see" the self-sacrificing miracle of Christ's birth. So vivid does the image of the child become that the poet bids himself

> Kiss Him, and with Him into Egypt go,
> With His kind mother, who partakes thy woe.

Kissing the babe becomes a symbol for the profound intimacy the poet feels with Christ and with the ancient sacraments of the church. Yet there is another, darker dimension to the poem. In the first and final stanzas of "La Corona," the poet's purpose is made clear. The "weaving" of the poetic coronet has been performed to rid Donne of his "low devout melancholy." For the poet of the anguished "Holy Sonnets," emotional rapport with God comes to pass only after great spiritual wrestling.

Herbert's "Christmas" is even stronger than "La Corona" in its autobiographical reference. It, too, is a meditation, a poetic devotion leading from the contemplation of characters and events in Scripture to a direct encounter with God. Following Ignatius Loyola's advice to meditators to "touch, handle, warmly kiss the clothes, the surrounding objects, the footprints and other things joined to such holy persons," Herbert enters his poem as a pilgrim searching for tokens of the newborn Christ. The reader eavesdrops on the poet-pilgrim's thoughts as he embarks on a doubt-ridden interior journey to find the infant. That journey is mined with obstacles. Herbert's soul falters and stumbles from sin. Only accidentally does the soul meet Christ, after exhausting itself with the "grief of pleasures" and coming close to despair:

> All after pleasures as I rode one day
>> My horse and I, both tir'd, body and mind,
>> With full cry of affections, quite astray;
> I took up in the next inn I could find.
>
> There when I came, whom found I but my dear,
>> My dearest Lord . . . ?

from LA CORONA

2. ANNUNCIATION

Salvation to all that will is nigh;
That All, which always is All everywhere,
Which cannot sin, and yet all sins must bear,
Which cannot die, yet cannot choose but die.
Lo, faithful Virgin, yields Himself to lie
In prison, in thy womb; and though He there
Can take no sin, nor thou give, yet He'll wear,
Taken from thence, flesh, which death's force may try.
Ere by the spheres time was created, thou
Wast in His mind, who is thy Son, and Brother,
Whom thou conceiv'st, conceived; yea thou art now
Thy Maker's maker, and thy Father's mother;
Thou hast light in dark; and shutst in little room,
Immensity cloistered in thy dear womb.

3. NATIVITY

Immensity cloistered in thy dear womb,
Now leaves His well-beloved imprisonment,
There He hath made Himself to His intent
Weak enough, now into our world to come;
But oh, for thee, for Him, hath the Inn no room?
Yet lay Him in this stall, and from the Orient,
Stars, and wisemen will travel to prevent
The effect of Herod's jealous general doom.
Seest thou, my soul, with thy faith's eyes, how He
Which fills all place, yet none holds Him, doth lie?
Was not His pity towards thee wondrous high,
That would have need to be pitied by thee?
Kiss Him, and with Him into Egypt go,
With His kind mother, who partakes thy woe.

JOHN DONNE

CHRISTMAS

All after pleasures as I rode one day,
 My horse and I, both tir'd, body and mind,
 With full cry of affections, quite astray;
I took up in the next inn I could find.
There when I came, whom found I but my dear,
 My dearest Lord, expecting till the grief
 Of pleasures brought me to him, ready there
To be all passengers' most sweet relief?
O Thou, whose glorious, yet contracted light,
 Wrapt in night's mantle, stole into a manger;
 Since my dark soul and brutish is thy right,
To Man of all beasts be not thou a stranger:
 Furnish and deck my soul, that thou mayst have
 A better lodging, than a rack, or grave.
The shepherds sing; and shall I silent be?
 My God, no hymn for thee?
My soul's a shepherd too; a flock it feeds
 Of thoughts, and words, and deeds.
The pasture is thy word: the streams, thy grace
 Enriching all the place.
Shepherd and flock shall sing, and all my powers
 Outsing the daylight hours.
Then we will chide the sun for letting night
 Take up his place and right:
We sing one common Lord; wherefore he should
 Himself the candle hold.
I will go searching, till I find a sun
 Shall stay, till we have done;
A willing shiner, that shall shine as gladly,
 As frost-nipt suns look sadly.
Then we will sing, and shine all our own day,
 And one another pay:
His beams shall cheer my breast, and both so twine,
Till ev'n his beams sing, and my music shine.

GEORGE HERBERT

A HYMN ON THE NATIVITY OF MY SAVIOUR

I sing the birth was born tonight,
The Author both of life and light,
 The angels so did sound it;
And like the ravished shepherds said,
Who saw the light, and were afraid,
 Yet searched, and true they found it.

The Son of God, th'eternal King,
That did us all salvation bring,
 And freed the soul from danger;
He whom the whole world could not take,
The Word which heaven and earth did make,
 Was now laid in a manger.

The Father's wisdom willed it so,
The Son's obedience knew no No,
 Both wills were in one stature;
And as that wisdom had decreed,
The Word was now made flesh indeed,
 And took on Him our nature.

What comfort by Him do we win,
Who made Himself the price of sin,
 To make us heirs of glory!
To see this Babe, all innocence,
A Martyr born in our defence,
 Can man forget this story?

BEN JONSON

Charles's tragedy was in failing to realize that a different course had been laid down in England for some time. The testy union of crown and Parliament forged so skillfully by Elizabeth was now dissolved. A talented, forceful Puritan wing who believed that one good man was worth more than one bad king now controlled Parliament and the monarch's purse. For the English king to brandish his scepter meant to court certain disaster.

A dangerous pattern of confrontation politics emerged. Over and over, the king would demand money; Parliament would wildly denounce the king; the king would angrily dissolve Parliament. While Puritans seethed, Charles governed for eleven years without Parliament and with the help of two advisors, Archbishop Laud and Sir Thomas Wentworth. 1641 proved a watershed year. In grave financial distress, Charles recalled Parliament. It responded by calling for Laud's and Wentworth's heads. His dignity shattered, Charles lost his nerve, too, and signed the death warrants of his two closest allies. "Put not your trust in Princes," snarled Wentworth as he mounted the scaffold. The once-mighty Archbishop Laud was clapped into prison and, four years later, lost his head under the executioner's sword.

Soon rebellion loomed in Scotland and Ireland, and as the king moved to crush Parliament's power, Wentworth's savage denunciation of his royal "protector" became a rallying cry for Englishmen flocking to fight under the banner of a new Parliamentarian hero, Oliver Cromwell. The crown's supporters mustered under the colors of Prince Rupert of the Rhine, grandson of James I and nephew of Charles.

Civil war rocked the nation.

THE TRIBE OF BEN

While Cavalier soldiers sharpened their swords, Cavalier poets took up their pens with a flourish and touched the last brilliant days of the Caroline court with a special grace. Their guiding spirit was Ben Jonson, who wrote the elaborate "masques" or musical extravaganzas that the Stuart court delighted in. Jonson served as unofficial poet laureate to the Stuart kings until illness lost him his royal pension in 1628. He and Robert Herrick, chief among the younger gentlemen-poets "sealed in the tribe of Ben," celebrated the sacred muse by paying public tribute to king, church, and nation. No inner turmoil disturbs the calm surface of Jonson's and Herrick's devotional poems, unlike the poems of fellow Anglicans

Donne and Herbert. Metaphysical intensity is disregarded for a typically Jonsonian goal of chiseled clarity and emotional restraint.

To Jonson and Herrick, faithful servants of the king, the Nativity is a symbol for the political status quo under the benevolent authority of crown and church. In "Hymn on the Nativity of My Saviour" (1616), Jonson asserts that Christ's birth is more than dogma. It is a "story" teaching the comforting message of contemporary man's lofty position as "heirs of glory." Jonson has demystified the tenet of holy birth by bringing it out of the realm of religious mystery and into the everyday sphere of utilitarian social truths.

Similarly, Herrick's winsome, graceful "Ode on the Birth of Our Saviour" (1648) makes clear the public end of devotional verse. In the last stanza, the adoring shepherds of the Gospels are magically transformed into seventeenth-century Londoners welcoming Christ into their midst as a fellow "free-born" citizen. With Christ's princely entry into its gates, London becomes a holy city, while the Stuarts become in poetry what they failed to become in history — holy kings:

> The Jews they did disdain Thee,
> But we will entertain Thee
> With glories to await here
> Upon Thy princely state here;
> And, more for love than pity,
> From year to year,
> We'll make Thee here
> A free-born of our city.

Jonson and Herrick are also the first poets to use the Nativity as a theme against which real events and real people are measured. In Jonson's "Epigram to the Queen, Then Lying In" (1630), the poet uses the Nativity for witty Royalist *vers de société*. The vain Henrietta Maria would have loved being greeted, "Hail, Mary, full of honours." It mattered little to the royal mother that her son's birth was no cause for joy to Puritan preachers. This was years before civil war would erupt, leaving the king beheaded and the Stuart line imperiled. To a family who fully believed that they ruled by divine design, what "prophaneness" could there be in a poet's pretty comparison between the first Prince of Peace and this swarthy new prince, the future Charles II? When was there ever such a happy occasion,

AN EPIGRAM TO THE QUEEN, THEN LYING IN

Hail Mary, full of grace, it once was said,
 And by an Angel, to the blessed'st Maid,
The Mother of our Lord: why may not I
 (Without prophaneness) yet, a poet, cry
Hail Mary, full of honours, to my Queen,
 The Mother of our Prince? When was there seen
(Except the joy that the first Mary brought,
 Whereby the safety of mankind was wrought)
So general gladness to an isle,
 To make the hearts of a whole nation smile,
As in this Prince? Let it be lawful, so
 To compare small with great, as still we owe
Glory to God. Then, Hail to Mary! spring
 Of so much safety to the realm, and King.

BEN JONSON

> So general gladness to an Isle,
> > To make the hearts of a whole Nation smile,
> As in this prince?

Herrick, too, followed Jonson's lead and wrote a number of gay, festive poems on Christmas customs that share the same brand of witty complaint as Jonson's epigram to the queen. "A Christmas Carol" (1648) is an ornate musical piece composed in collaboration with the court musician Henry Lawes in honor of Charles I. Despite its title, it is not a carol, but an artificial "folk" lyric for the pageant-loving Caroline court, which loved to ape the pastoral customs of rural folk. Herrick turns the Nativity into a gay spectacle of folly and music. The newborn "King," the "Darling of the world," has an earthly counterpart, Charles I, blessing the people like Christ blessing his flock. The merry Christmas throng gather about

> > To do Him honour; who's our King,
> > And Lord of all this revelling.

Herrick's "carol" is a precious, stylized Nativity poem in the Cavalier tradition. It also captures a typical picture of Charles I that his admirers cherished throughout history. Through Herrick's adoring eyes, we see the doomed king — small, elegantly dressed, standing slightly apart from the crowd with his characteristically "sweet, grave, melancholy" countenance. The days left to Charles and his "flock" were few. Few, too, were the days left to the devotional poets of the Anglican church, the church of the Stuart kings. The flowering of seventeenth-century Nativity poems in English literature was all too brief. By 1649, the year of the king's death, it would be crushed by Puritan hatred for the Christmas holy day.

CATHOLICS IN EXILE

With crown and Parliament squared off, all revelry ceased. Charles I's glittering court split and scattered. Many, like the poet Richard Lovelace, followed their king into battle, laughing and joking in true Cavalier fashion as they readied their swords for the fray. Others, loyal to the queen, went with her in 1644 into France, where they lived as pensioners of her young nephew, Louis XIV, and his evil genius, Cardinal Mazarin.

Branded a traitor by Parliament, Henrietta Maria remained confident, for she fully believed that the wicked English "heretics" would be crushed into submission by an absolute, preferably Catholic monarchy. Her small, impoverished

A CHRISTMAS CAROL

Sung to the King
in the Presence at Whitehall

Chorus

What sweeter music can we bring,
Than a carol, for to sing
The birth of this our heavenly King?
Awake the voice! Awake the string!
Heart, ear, and eye, and every thing
Awake! the while the active finger
Runs division with the singer.

1.

Dark and dull night, fly hence away,
And give the honor to this day,
That sees December turned to May.

2.

If we may ask the reason, say
The why and wherefore all things here
Seem like the springtime of the year?

3.

Why does the chilling winter's morn
Smile, like a field beset with corn?
Or smell, like to a mead newshorn,
Thus, on the sudden? *4.* Come
and see

The cause, why things thus fragrant be:
'Tis He is born, whose quickening birth
Gives life and luster, public mirth,
To Heaven and the under-Earth.

Chorus

We see Him come, and know Him ours,
Who, with His sunshine, and His showers,
Turns all the patient ground to flowers.

1.

The Darling of the world is come,
And fit it is, we find a room
To welcome Him. *2.* The nobler part
Of all the house here, is the heart,

Chorus

Which we will give Him; and bequeath
This holly, and this ivy wreath,
To do Him honour; who's our King,
And Lord of all this revelling.

ROBERT HERRICK

AN ODE ON THE BIRTH OF OUR SAVIOUR

In numbers, and but these few,
I sing Thy birth, O Jesu!
Thou pretty baby, born here
With superabundant scorn here:
Who for Thy princely port here,
 Hadst for Thy place
 Of birth, a base
Outstable for Thy court here.

Instead of neat enclosures
Of interwoven osiers;
Instead of fragrant posies
Of daffodils and roses;
Thy cradle, Kingly stranger,
 As gospel tells,
 Was nothing else
But here a homely manger.

But we with silks (not crewels)
With sundry precious jewels,
And lily-work will dress Thee;
And as we dispossess Thee
Of clouts, we'll make a chamber,
 Sweet Babe, for Thee
 Of ivory,
And plastered round with amber.

The Jews they did disdain Thee,
But we will entertain Thee
With glories to await here
Upon Thy princely state here;
And, more for love than pity,
 From year to year,
 We'll make Thee here
A free-born of our city.

ROBERT HERRICK

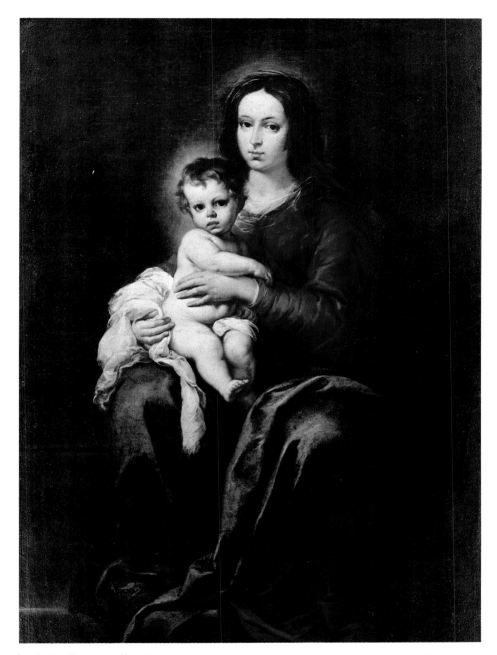

Plate 13. *Bartolomé Esteban Murillo*, The Virgin and Jesus *(mid-seventeenth cent.)*
Murillo demonstrates the portrait techniques made popular in the Cavalier court of Stuart England by Rubens and Van Dyke. Very popular in his native Spain in the mid-seventeenth century, Murillo satisfied the demand for slightly sentimental religious themes created by the Counter-Reformation. Prado, Madrid (Scala, New York/Florence)

court in Paris became a haven for Catholic émigrés and a nest of Anglo-Catholic intrigue. These English "papists" were never really a threat to English Protestantism. They were feared and hated by Anglicans and Puritans alike, however, for they were the chief English connection to the powerful anti-Protestant reaction that had been sweeping Europe for nearly a century, the Catholic Counter-Reformation. In France and Spain especially, the forces of the Counter-Reformation had gathered steam and were brutally rooting out Protestants through the legalized butchery of the Inquisition and the bloodbaths of the Fronde. The English Catholic party never came to dominate their country as did the parties of the Catholic monarchs of Spain and France. When civil war came, the English Catholics, like Henrietta Maria, were literally homeless. Declared anathema by the Puritans, they were forced in many cases to flee to the continent, where, destitute and in disarray, they were barely tolerated and often abused.

These exiles, too, had a poet, Richard Crashaw, who set down in verse the solitary ecstasies of the English Catholic. The scion of a militantly Puritan family, Crashaw had turned to the mystical Anglican community of Nicholas Ferrar at Little Gidding, scorned by Puritans as "that Arminian nunnery." When he fled the Parliamentarian armies to France, Crashaw made a celebrated conversion to Catholicism, briefly came under the protection of the English queen in Paris, and ended his days at Basilica Church in Loreto, where fellow Catholics, embarrassed by his devotional excesses, supposedly murdered him.

The magnificent "In the Holy Nativity of Our Lord God" (1652) is the sole English Nativity poem in the seventeenth century that exhibits a continental Counter-Reformation devotion to the infant Jesus and his mother. Under the influence of European mysticism, elements that had not been present in English devotional verse since the late Middle Ages resurface in Crashaw's poem: Crashaw reasserts anew the humanity of infant and mother, a concept that runs counter to the redemptive, spiritualized Christ of the Protestants Donne, Herbert, and especially Milton and Vaughan. Like his baroque counterpart, the Italian poet Marino, Crashaw revels in Christ's and the Virgin's beauty:

> See, see, how soon his new-bloomed cheek
> 'Twixt's mother's breasts is gone to bed!
> Sweet choice, said we; no way but so,
> Not to lie cold, yet sleep in snow.

Yet Crashaw's hymn shows a sensuousness atypical even of continental baroque poets. The Nativity is transformed into a series of sensuous images and

Commonwealth and led Cromwell, the enemy of kings, to adjourn Commons with the angry words, "Depart I say, in the name of God, go!" In 1653, he would declare himself Lord Protector and rule England as a king without a crown. Cromwell's own complex personality mirrored the conflict within the Puritan party. He was a music lover who destroyed priceless works of religious art; a man of incredible energy who fell victim to deep melancholia. His tenderness and his brutality were legendary. The man who helped the wife of an enemy escape the grim battlefield where her husband lay slain also laid waste the Irish Catholic strongholds of Drogheda and Wexford and mercilessly slaughtered the women, children, and priests who pleaded for quarter.

Under Cromwell's leadership, the Puritans threw off the "eternal truths" of the Renaissance and imposed new revolutionary "truths" based on reason and individual conscience. This revolution may not have been as complete a social upheaval as France's in 1789; nevertheless, its impact on English life and letters was enormous, and after Cromwell, England was never quite the same. Of course, the sober rule of Cromwell was not to everyone's liking. The Puritans destroyed all images and artifacts remotely tainted with "papism." Theaters were shut down. Caroling, dancing, and sports were forbidden. All holy days except the Sabbath were declared illegal. The Passion and the Nativity faded from the calendar. The pleasure-loving English rankled under this stern rule, and sporadic outbursts continued to annoy the Puritan regime. Indeed, Charles's last warning must have returned to haunt a chastened English people, especially when it soon became clear that a Puritan republic would not bring the kingdom of God any closer on earth.

When the wars had faded to a dim memory, men would remember the severity, not the great libertarian vision of the Puritans. The blind Puritan poet John Milton had once hailed the victorious Lord General Cromwell as "our chief of men," leading England to a brilliant future of "peace and truth." Soon he would look back on the Protectorate as that "short but scandalous night of interruption." As Milton foresaw, these years without a monarch would be only a hiatus, a brief "Interregnum" in English history. The Stuart line would return in 1660 under Charles II, son of the martyred king, and England would never throw off its monarchs again.

PURITANS AND THE NATIVITY

The Puritans despised the "superstitious festivals" that had accrued around the Christ-mass observance. When they took power, they singled out Christmas as

a primary target for their campaign against "un-Sunday" celebrations. Throughout the Commonwealth and Protectorate, Christmas was rigidly suppressed, while the English grew more and more defiant. Anti-Puritan Christmas carols and ballads were circulated underground. Mumming, feasting, and Christmas rites were held right under the Puritans' noses. No one was dismayed if Cromwell's men invaded the Christmas festivities. The rioting and "skull cracking" that ensued became an expected, even welcome part of the illegal ceremonies, especially when the rabble was able to cudgel the soldiers and magistrates senseless. Such was the case one December 25 during the Interregnum when the arrest of a few subordinate tradesmen caused an angry mob to "rescue their fellowes, and beat the Mayor and Alderman into their houses, and then cry Conquest."

To the average Puritan foot soldier, Christmas prayers meant prayers to the hated Charles Stuart, the Antichrist, the son of the accursed Man of Blood. Clearly, the symbols of the Nativity no longer moved the Puritans. The gospel image of a suffering Christ in a manger was foreign to the Puritan notion of a risen, spiritual Christ, a Second Adam, victorious over flesh and the devil. The Calvinist scholar James Ussher spoke for all seventeenth-century Puritans when he declared the incarnate Christ to be "that holy thing which was borne of Mary . . . called the Son of God."

Yet Puritanism, a faith hostile to the pagan Yule tradition and to the image of a newborn human Christ, also gives us the finest Nativity poem in English literature, John Milton's "On the Morning of Christ's Nativity" (1629). John Milton's first great poem, the "Nativity Ode" is a rare, exceptional work drawing upon all the major strands of Nativity verse from medieval through Renaissance times and shaping all of these into a personal manifesto for Puritanism. It is not the Christ child of the Bible that Milton celebrates, but Christ the king, the remote, awesome figure familiar in Puritan thought and identified with the power of the Word of God to establish the kingdom of heaven on earth. Milton drew his militant Christ from the chaos of seventeenth-century politics. In *The Reason of Church Government*, he depicted the confrontation of Anglican and Puritan forms of government as a battle between the flaming-eyed, warrior-Christ of Revelation and the evil forces of "prelaty":

> I add one thing more to those great ones that are so fond of prelaty: this is certain, that the gospel being the hidden might of Christ, as hath been heard, hath ever a victorious power joined with it, like him in the book of Revelation that went forth on the white horse with his bow and his crown, conquering and to conquer.

Milton's "Ode" thus creates a new, Puritan mythology surrounding the newborn Christ. Except for a few references to the scriptural Nativity, he avoids treating Christ as a real infant in the manger. Milton's Christ is a warlike figure like the Christ of Revelation, a deity enthroned in heaven and an active participant in God's glory. Milton even reshapes the events in Christ's life to coincide with a Puritan evangelical view of sacred history. In the "Ode," history does not culminate in Christ's Passion, but in his apotheosis as the judge at the end of time. The newborn Christ is a small but mighty warrior, victorious over pagan deities at the apocalypse. Christ's infant features, his rags, his eyes, his hands, contain the very seeds of his strength. His swaddling bands, like the powerful arms of the newborn Hercules who strangled the snakes, bind the "damned crew." The light from this remarkable "Sun" blinds the eyes of the pagan gods. His "dreaded Infant's hand" reaches out to grasp the sorcerers of Osiris:

> He feels from Judah's land
> The dreaded Infant's hand,
> The rays of Bethlehem blind his dusky eyn;
> Nor all the gods beside,
> Longer dare abide,
> Not Typhon huge ending in snaky twine:
> Our Babe, to show his Godhead true,
> Can in his swaddling bands control the damnèd crew.

Milton's "On the Morning of Christ's Nativity" occupies a unique position in English devotional poetry. It is the supreme achievement in Nativity verse while it affirms the poet's Puritanism, a faith that was hostile to the notion of the Nativity and the poetic tradition that supported it. Yet Milton so brilliantly creates that rarity of poetic achievement, a Puritan devotional poem, that the "Ode" advances and reshapes the entire tradition of English Nativity verse and becomes an important, influential milestone in that tradition.

ODE: ON THE MORNING
OF CHRIST'S NATIVITY

This is the month and this the happy morn
Wherein the Son of Heaven's eternal King,
Of wedded Maid, and Virgin Mother born,
Our great redemption from above did bring;
For so the holy sages once did sing,
 That he our deadly forfeit should release,
And with his Father work us a perpetual peace.

That glorious form, that light unsufferable,
And that far-beaming blaze of majesty,
Wherewith he wont at Heaven's high council-table,
To sit the midst of Trinal Unity,
He laid aside; and here with us to be,
 Forsook the courts of everlasting day,
And chose with us a darksome house of mortal clay.

Say Heavenly Muse, shall not thy sacred vein
Afford a present to the Infant God?
Hast thou no verse, no hymn, or solemn strain,
To welcome him to this his new abode,
Now while the Heaven by the sun's team untrod,
 Hath took no print of the approaching light,
And all the spangled host keep watch in squadrons bright?

See how from far upon the Eastern road
The star-led wizards haste with odors sweet:
O run, prevent them with thy humble ode,
And lay it lowly at his blessed feet;
Have thou the honor first, thy Lord to greet,
 And join thy voice unto the angel choir,
From out his secret altar touched with hallowed fire.

THE HYMN

It was the winter wild
While the Heaven-born child
 All meanly wrapped in the rude manger lies;
Nature in awe to him
Had doffed her gaudy trim,
 With her great Master so to sympathize;
It was no season then for her
To wanton with the sun, her lusty paramour.

Only with speeches fair
She woos the gentle air
 To hide her guilty front with innocent snow,
And on her naked shame,
Pollute with sinful blame,
 The saintly veil of maiden white to throw,
Confounded that her Maker's eyes
Should look so near upon her foul deformities.

But he her fears to cease
Sent down the meek-eyed Peace;
 She, crowned with olive green, came softly sliding
Down through the turning sphere,
His ready harbinger,
 With turtle wing the amorous clouds dividing,
And waving wide her myrtle wand,
She strikes a universal peace through sea and land.

No war or battle's sound
Was heard the world around:
 The idle spear and shield were high uphung;
The hookèd chariot stood
Unstained with hostile blood;
 The trumpet spake not to the armèd throng;
And kings sat still with awful eye,
As if they surely knew their sovereign Lord was by.

But peaceful was the night
Wherein the Prince of Light
 His reign of peace upon the earth began:
The winds, with wonder whist,
Smoothly the waters kissed,
 Whispering new joys to the mild ocean,
Who now hath quite forgot to rave,
While birds of calm sit brooding on the charmèd wave.

The stars with deep amaze
Stand fixed in steadfast gaze,
 Bending one way their precious influence,
And will not take their flight
For all the morning light,
 Or Lucifer that often warned them thence;
But in their glimmering orbs did glow,
Until their Lord himself bespake, and bid them go.

And though the shady gloom
Had given day her room,
 The sun himself withheld his wonted speed,
And hid his head for shame,
As his inferior flame
 The new-enlightened world no more should need;
He saw a greater Sun appear
Than his bright throne or burning axletree could bear.

The shepherds on the lawn,
Or ere the point of dawn,
 Sat simply chatting in a rustic row;
Full little thought they then
That the mighty Pan
 Was kindly come to live with them below;
Perhaps their loves, or else their sheep,
Was all that did their silly thoughts so busy keep.

When such music sweet
Their hearts and ears did greet,

As never was by mortal finger struck,
Divinely warbled voice
Answering the stringèd noise,
 As all their souls in blissful rapture took;
The air such pleasure loath to lose,
With thousand echoes still prolongs each heavenly close.

Nature that heard such sound
Beneath the hollow round
 Of Cynthia's seat, the airy region thrilling,
Now was almost won
To think her part was done,
 And that her reign had here its last fulfilling;
She knew such harmony alone
Could hold all heaven and earth in happier union.

At last surrounds their sight
A globe of circular light,
 That with long beams the shamefaced Night arrayed;
The helmèd Cherubim
And swordèd Seraphim
 Are seen in glittering ranks with wings displayed,
Harping in loud and solemn choir
With unexpressive notes to Heaven's new-born heir.

Such music (as 'tis said)
Before was never made,
 But when of old the sons of morning sung,
While the Creator great
His constellations set,
 And the well-balanced world on hinges hung,
And cast the dark foundations deep,
And bid the weltering waves their oozy channel keep.

Ring out, ye crystal spheres,
Once bless our human ears
 (If ye have power to touch our senses so),

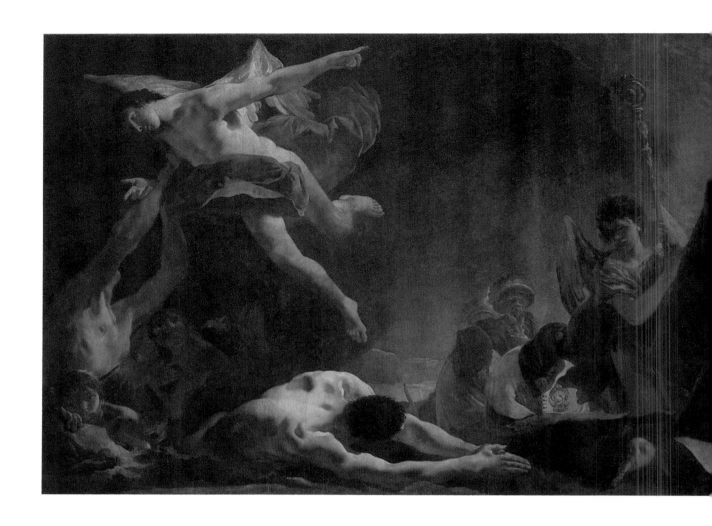

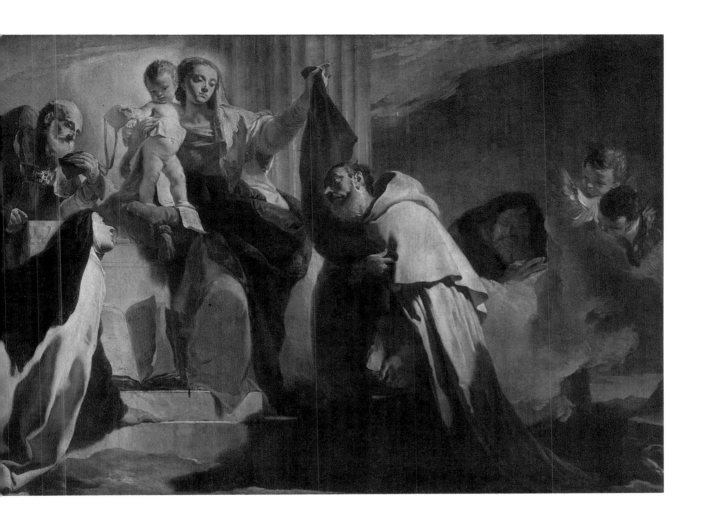

Plate 15. *Giovanni Battista Tiepolo,* The Madonna of Carmel *(c. 1740)*

> *Nature in awe to him*
> *Had doffed her gaudy trim,*
> > *With her great Master so to Sympathize.*

Although culturally and chronologically far removed from Milton's England, Tiepolo's composition captures the same sense of the cosmic impact of the Nativity as that conveyed in Milton's "Ode." Pinacoteca, Brera (Scala, New York/Florence)

And let your silver chime
Move in melodious time,
 And let the bass of heaven's deep organ blow;
And with your ninefold harmony
Make up full consort to the angelic symphony.

For if such holy song
Enwrap our fancy long,
 Time will run back and fetch the age of gold,
And speckled Vanity
Will sicken soon and die,
 And leprous Sin will melt from earthly mould,
And hell itself will pass away,
And leave her dolorous mansions to the peering day.

Yea, Truth and Justice then
Will down return to men,
 Orbed in a rainbow; and, like glories wearing,
Mercy will sit between,
Throned in celestial sheen,
 With radiant feet the tissued clouds down steering;
And heaven as at some festival
Will open wide the gates of her high palace hall.

But wisest Fate says no,
This must not yet be so;
 The Babe lies yet in smiling infancy,
That on the bitter cross
Must redeem our loss,
 So both himself and us to glorify;
Yet first, to those ychained in sleep,
The wakeful trump of doom must thunder through the deep

With such a horrid clang
As on Mount Sinai rang
 While the red fire and smouldering clouds outbreak;
The aged Earth, aghast
With terror of that blast,

Shall from the surface to the centre shake,
When at the world's last session
The dreadful Judge in middle air shall spread his throne.

And then at last our bliss
Full and perfect is,
 But now begins; for from this happy day
The old Dragon underground,
In straiter limits bound,
 Not half so far casts his usurpèd sway,
And wroth to see his kingdom fail,
Swingès the scaly horror of his folded tail.

The oracles are dumb,
No voice or hideous hum
 Runs through the archèd roof in words deceiving.
Apollo from his shrine
Can no more divine,
 With hollow shriek the steep of Delphos leaving.
No nightly trance or breathèd spell
Inspires the pale-eyed priest from the prophetic cell.

The lonely mountains o'er,
And the resounding shore,
 A voice of weeping heard, and loud lament;
From haunted spring and dale
Edged with poplar pale
 The parting Genius is with sighing sent;
With flower-inwoven tresses torn
The nymphs in twilight shade of tangled thickets mourn.

In consecrated earth,
And on the holy hearth,
 The Lars and Lemures moan with midnight plaint;
In urns and altars round,
A drear and dying sound
 Affrights the flamens at their service quaint;

And the chill marble seems to sweat,
While each peculiar power forgoes his wonted seat.

Peor and Baalim
Forsake their temples dim,
　　With that twice-battered god of Palestine,
And moonèd Ashtaroth,
Heaven's queen and mother both,
　　Now sits not girt with tapers' holy shine;
The Libyc Hammon shrinks his horn,
In vain the Tyrian maids their wounded Thammuz mourn.

And sullen Moloch, fled,
Hath left in shadows dread
　　His burning idol all of blackest hue;
In vain with cymbals' ring
They call the grisly king,
　　In dismal dance about the furnace blue;
The brutish gods of Nile as fast,
Isis and Orus, and the dog Anubis haste.

Nor is Osiris seen
In Memphian grove or green,
　　Trampling the unshowered grass with lowings loud;
Nor can he be at rest
Within his sacred chest,
　　Naught but profoundest hell can be his shroud;
In vain with timbreled anthems dark
The sable-stolèd sorcerers bear his worshipped ark.

He feels from Judah's land
The dreaded Infant's hand,
　　The rays of Bethlehem blind his dusky eyn;
Nor all the gods beside
Longer dare abide,
　　Not Typhon huge ending in snaky twine:
Our Babe, to show his Godhead true,
Can in his swaddling bands control the damnèd crew.

So when the sun in bed,
Curtained with cloudy red,
 Pillows his chin upon an orient wave,
The flocking shadows pale
Troop to the infernal jail;
 Each fettered ghost slips to his several grave,
And the yellow-skirted fays
Fly after the night-steeds, leaving their moon-loved maze.

But see, the Virgin blest
Hath laid her Babe to rest.
 Time is our tedious song should here have ending;
Heaven's youngest-teemèd star
Hath fixed her polished car,
 Her sleeping Lord with handmaid lamp attending;
And all about the courtly stable
Bright-harnessed angels sit in order serviceable.

JOHN MILTON

THE SEARCH

The fracturing of the ordered Elizabethan universe predicted by John Donne in "An Anatomy of the World" had been brought to fruition in the turbulent 1640's and 1650's. Many men and women could now join the prescient Donne in lamenting, " 'Tis all in pieces, all coherence gone." The partisan loyalties that had seemed so clear-cut in the bloody skirmishes of Edgehill and Worcester had by the late 1650's blurred into a deeply unsatisfying muddle. Men and women who had once shouted for Charles I's head now remembered their late sovereign's dignity as the executioner raised his sword. A new wind was rising across the Channel in France where the young Charles Stuart, uncrowned King of England, waited out his exile. Loyal Parliamentarians, watching their Protector slowly weaken under debilitating bouts of malaria, sensed this new drift and began secret negotiations with Charles's court-in-exile. Already the great Parliamentarian general Sir Thomas Fairfax had retired to the country to await the monarchy's return. Soon, there were outbursts of Royalist sentiment among the people themselves: Charles's picture appeared mysteriously in the London streets. One man entered the Royal Exchange, walked up to where a statue of Charles I once stood, and on the empty base painted the words: "Long Live King Charles II." The English people waited and watched.

The melancholy voice of the Welsh poet Henry Vaughan rises out of the bleak middle years of the seventeenth century to speak for the confused, wary masses. Shattered by the Royalists' defeat, Vaughan retired from a promising legal career in London to spend the rest of his days as a country doctor in his native Wales. His haunting, incandescent poems, some of the finest in all of English literature, remain as mysterious as Vaughan himself. They are cryptic, esoteric works, reflecting a soul in turmoil, a religious life adrift, for Vaughan was a Royalist without a king, an Anglican without a church, a poet without a tradition. The title of one of his most brilliant poems, "The Search" (1650), describes his overriding mission as a religious poet. Like his mentor, George Herbert, Vaughan reaches for sublimity, for a glimpse of God himself. Yet the divine vision that bursts so easily upon "the holy Mr. Herbert" is for Vaughan a frail will-o'-the-wisp. Vaughan seeks and seeks in vain for his visionary ideal, only to have it flare forth blindingly and quickly disappear.

The Nativity or Incarnation is the pivotal theme in Vaughan's verse. Vaughan, however, removed that theme from the frame of Christ's life so that it takes on a private meaning. Since the historic Christ is inaccessible to Vaughan in a fallen,

Puritan world, the Nativity becomes a metaphor for an ideal and tragically un-attainable universe. In "The Incarnation, and Passion," Christ's example of divine humility shows, by contrast, how far man has fallen. "Christ's Nativity II" and "The Shepherds" make clear that man's present corruption stems from his corrupt society, here identified with "Salem," the Puritan regime, which has wickedly outlawed the celebration of Christ's birth:

> Can neither Love, nor suff'rings bind?
> Are we all stone, and Earth?
> Neither his bloody passions mind,
> Nor one day bless his birth?
> Alas, my God! Thy birth now here
> Must not be numbered in the year.
> from "Christ's Nativity II"

Two subsequent Christmas poems further develop the political dimensions of the Nativity theme. Written at the height of Puritan power, "The Nativity" (1656) mourns a "poor Galilee" where darkness abides and no holy birth renews the world. Nevertheless, the return of the "true" church in 1660 did not, in Vaughan's eyes, wipe the mists of sin away. In "The True Christmas" (1678), he recoils from the "heathen ways" of Christmas revelers under the Restoration who fail to learn from the mean estate of the newborn Christ.

Vaughan's obsession with man's "frail nature" leads him further from the symbols of the old faith into a more private realm. In his most imaginative poem on the life of Christ, "The Search," Christ has become so inaccessible that he has fled the very scenes of his infancy, maturity, and death. All that is left is a "small, bright sparkle" in the ashes, originally the crèche, a glowing reminder of the inherent divinity in the world that may yet re-ignite the whole. Vaughan's search for meaningful new religious symbols leads him in "The Retreat" into the unex-plored regions of his own soul. Since Christ has left the world and corruption has set in, the symbol for innocence becomes not the newborn Christ but the ideal human child:

> Happy those early days, when I
> Shined in my angel-infancy!
> Before I understood this place
> Appointed for my second race,
> Or taught my soul to fancy aught
> But a white celestial thought.

To laymen like Henry Vaughan, ancient symbols and mysteries like the Incarnation and Nativity had begun to exhaust their meaning and held no more relevance for their lives. A new secular, scientific age was dawning out of the confusion of religious wars and civil strife. Reason was its guiding principle. Progress was its motto. The urbane John Dryden, who had once eulogized the dead Cromwell, easily reversed his political loyalties two years later to celebrate the restoration of Charles II. Gracefully, with hardly a glance backward, Dryden stepped into the glittering world of the Restoration as its finest poetic spokesman:

> All, all of a piece throughout:
> The chase had a beast in view;
> The wars brought nothing about;
> The lovers were all untrue.
> 'Tis well an old age is out,
> And time to begin a new.
>
> (*The Secular Masque*, 1700)

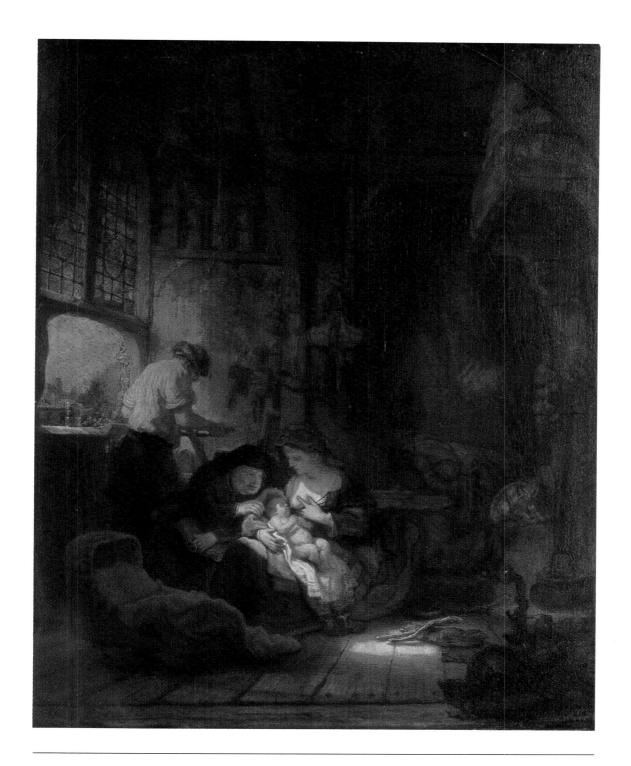

THE SEARCH

'Tis now clear day: I see a rose
Bud in the bright East, and disclose
The pilgrim-sun; all night have I
Spent in a roving ecstasy
To find my Saviour; I have been
As far as Bethle'm, and have seen
His inn, and cradle; being there
I met the wise-men, asked them where
He might be found, or what star can
Now point him out, grown up a man?
To Egypt hence I fled, ran o'er
All her parched bosom to Nile's shore
Her yearly nurse; came back, enquired
Amongst the doctors, and desired
To see the temple, but was shown
A little dust, and for the town
A heap of ashes, where some said
A small bright sparkle was a bed,
Which would one day (beneath the pole,)
Awake, and then refine the whole.

 Tired here, I come to Sychar; thence
To Jacob's well, bequeathèd since
Unto his sons, (where often they
In those calm, golden evenings lay
Wat'ring their flocks, and having spent
Those white days, drove home to the tent
Their well-fleeced train); and here (O fate!)
I sit, where once my Saviour sat;
The angry spring in bubbles swelled
Which broke in sighs still, as they filled,
And whispered, Jesus had been there
But Jacob's children would not hear.
Loath hence to part, at last I rise

But with the fountain in my eyes,
And here a fresh search is decreed
He must be found, where he did bleed;
I walk the garden, and there see
Ideas of his agony,
And moving anguishments that set
His blest face in a bloody sweat;
I climbed the hill, perused the cross
Hung with my gain, and his great loss,
Never did tree bear fruit like this;
Balsam of souls, the body's bliss;
But, O his grave! where I saw lent
(For he had none,) a monument,
An undefiled, and new-hewed one,
But there was not the corner-stone;
Sure (then said I,) my quest is vain,
He'll not be found, where he was slain,
So mild a Lamb can never be
'Midst so much blood, and cruelty;
I'll to the wilderness, and can
Find beasts more merciful than man,
He lived there safe, 'twas his retreat
From the fierce Jew, and Herod's heat,
And forty days withstood the fell,
And high temptations of hell;
With seraphins there talkèd he
His father's flaming ministry,
He heav'ned their walks, and with his eyes
Made those wild shades a paradise,
Thus was the desert sanctified
To be the refuge of his bride;
I'll thither then; see, it is day,
The sun's broke through to guide my way.

But as I urged thus, and writ down
What pleasures should my journey crown,
What silent paths, what shades, and cells,
Fair, virgin-flowers, and hallowed wells

I should rove in, and rest my head
Where my dear Lord did often tread,
Sug'ring all dangers with success,
Me thought I heard one singing thus;

1.
Leave, leave, thy gadding thoughts;
Who pores
and spies
Still out of doors
descries
Within them nought.

2.
The skin, and shell of things
Though fair,
are not
Thy wish, nor prayer
but got
My mere despair
of wings.

3.
To rack old elements,
or dust
and say
Sure here he must
needs stay
Is not the way,
nor just.

Search well another world; who studies this,
Travels in clouds, seeks manna, where none is.

Acts chap. 17, ver. 27, 28
That they should seek the Lord, if happily they might feel
after him, and find him, though he be not far off from
every one of us, for in him we live, and move, and
have our being.

HENRY VAUGHAN

THE RETREAT

Happy those early days, when I
Shined in my angel-infancy!
Before I understood this place
Appointed for my second race,
Or taught my soul to fancy aught
But a white celestial thought;
When yet I had not walked above
A mile or two from my first love,
And looking back, at that short space,
Could see a glimpse of his bright face;
When on some gilded cloud, or flower,
My gazing soul would dwell an hour,
And in those weaker glories spy
Some shadows of eternity;
Before I taught my tongue to wound
My conscience with a sinful sound,
Or had the black art to dispense
A several sin to every sense,
But felt through all this fleshly dress
Bright shoots of everlastingness.

 O how I long to travel back,
And tread again that ancient track!
That I might once more reach that plain
Where first I left my glorious train;
From whence the enlightened spirit sees
That shady City of Palm-trees.
But (ah!) my soul with too much stay
Is drunk, and staggers in the way.
Some men a forward motion love,
But I by backward steps would move,
And when this dust falls to the urn
In that state I came, return.

HENRY VAUGHAN

IV *Little Lamb, Who Made Thee?*

THE EIGHTEENTH AND NINETEENTH CENTURIES

THE SEA OF FAITH RECEDES

THE restoration of the Stuarts to the English throne in 1660 brought an end to the great tide of devotional verse that decades of religious ferment had unleashed. Over the next two hundred years, the Nativity theme virtually vanished from the foreground of English literature, while the artistic level of religious poetry declined markedly. After years of austerity, England commenced a vigorous period of prosperity and expansion that outlasted the Stuart and Hanoverian dynasties and reached a zenith in the long, fruitful reign of Victoria. No more would wars be fought in the name of religion. The sectarian clash of Anglican and Dissenter on history's center stage gave way to the political rivalry of Whig and Tory.

Charles II's accession accomplished a literary as well as a political revolution. Creative energies long bottled by the Puritans burst forth exuberantly in literature that generally ignored religious themes for unabashedly worldly concerns. Many commoners wept over the agonies of John Bunyan's earnest Christian as he made his way through a perilous landscape to the holy city of Beulah. But other sober folk still joined the huge crowds jamming the newly restored theaters to enjoy the salacious repartee of Etherege's Sir Fopling Flutter or the complicated romance of Congreve's Mirabell and Millamant. The obscure theological language and visionary flights of Donne and Herbert were displaced by a witty, neoclassical vein of poetry hearkening back to Jonson and his "tribe" of Cavaliers. This rational, civilized notion of verse would be further refined by Alexander Pope in the eighteenth century, then overturned by the Romantic naturalism and Victorian sobriety of subsequent generations of writers. From the Restoration on, poets' attention turned more and more to things of this world, less and less to heaven.

Throughout the Middle Ages and Renaissance, the birth of Christ had served as a crucial symbol for God's miraculous, mysterious intervention in human affairs. However, in an age dominated increasingly by reason and "good sense," Nativity

poems begin to decline in artistry and originality. Eighteenth-century Nativity poems make up in piety what they lack in power. The best of them reflect a radical grassroots religious reaction to prevailing secular trends, as do the Protestant evangelical hymns of Isaac Watts, Charles Wesley, and Christopher Smart. Most nineteenth-century poets ignore the Nativity, although the theme does undergo a fascinating secular metamorphosis in Romantic verse. While parodying Milton's "Nativity Ode," for example, the opening lines of William Blake's *Europe* also set forth the poet's belief in the cleansing power of political revolution through the terrible birth of "Orc," history's "secret child":

> The deep of winter came:
> What time the secret child
> Descended thro' the Orient gates of the eternal day
> War ceas'd, & all the troops like shadows fled
> To their abodes.

The scriptural Nativity enjoys a small revival in late Victorian poetry. However, by this stage of the theme's evolution, it has shrunk in religious significance until it is little more than a private symbol. Alfred Tennyson yokes Christian motifs to the Christmas bells of *In Memoriam*, an image conveying the poet's own emotional rebirth after mourning the tragic death of his dearest friend. In Algernon Charles Swinburne's "Three Damsels in the Queen's Chamber," the narrative framework of the gospel Nativity story survives while doctrine disappears. The sensualist Swinburne transmogrifies the scriptural event into an ingenious and erotic myth. The very scarcity and diversity of eighteenth- and nineteenth-century Nativity poems show how deep a blow had been struck against the craft and calling of the devotional poet by the Age of Reason and the bitter war between religion and science that ensued.

THE COSMIC CLOCKMAKER

Stone by stone, the mighty edifice of Renaissance Christianity was dismantled by waves of freethinkers who still considered themselves proper Christians. The intricate tapestry of religious reform in Restoration England soon produced a flexible, liberal strain of Protestantism, refined in the pulpits of latitudinarian divines and in the scholarly writings of the Cambridge Platonists. The "New Science," too, began to encroach rapidly on the vast terrain of religious orthodoxy. The neophyte scientific movement's most enthusiastic supporter was the cynical,

erudite Charles II himself, who established the "Royal Society of London for Promoting Natural Knowledge" shortly after his coronation. The Royal Society was immediately championed by leading churchmen who hailed the New Science as a handmaiden of God. In his *History of the Royal Society*, Bishop Thomas Sprat of Rochester passionately urged all Christians to forsake the "enthusiasm" of the past, arguing that science was perfectly consistent with theology. Yet it soon became apparent to "religious philosophers" that science was not the sister of faith. The inductive method of intellectual inquiry first launched by James I's brilliant Lord Chancellor, Francis Bacon, had turned unexpectedly into a devastating weapon against the church. The pious Isaac Newton, the Royal Society's most celebrated president, charted a universe governed by fixed mathematical laws, which many saw displacing God's intimate hand in the operations of nature and the affairs of men. Church divines heaped scorn on the iconoclastic philosopher Thomas Hobbes, for his jaundiced view of mankind threw doubt on the truth of revealed religion. Hobbes himself did not deny that God spoke to men through "dreams, visions, voice and inspiration"; nevertheless, only a fool, he claimed, would believe another man's visionary accounts, since the dreamer, "being a man, may err, and which is more, may lie."

The intellectual debate gave rise at the turn of the eighteenth century to Deism, a rational theology identifying God with the processes of nature. Although the Deists claimed to be devout Christians, their insistence on a remote "clockmaker" God rendered obsolete the central revelations of Christianity, the Bible, and the life of Christ. The Deists' ascendance in England was uneasy and short. They were denounced from pulpit to pulpit while their most controversial positions were hotly contested in a war of pamphlets. By the middle of the eighteenth century, a huge burst of evangelical lay piety arrested the spread of Deistic theology, leaving the Deist mantle to fall to a younger group of secular *philosophes* on the continent. As quarrelsome as they were in their heyday, however, the English Deists exerted an immense, long-lasting influence on English thought. Even their worst enemies read their works voraciously and handed them down to the next generation of thinkers. Eccentric Deists like Thomas Woolston, notorious for his hysterical outbursts against "whifflers of divinity," may have been laughed at in his day. Yet Woolston's diatribes, along with other, more reasonable Deist polemics, helped weaken the credibility of the Bible. The Deists' charges against church dogma were simply too sweeping to ignore. They labeled the miracles of Christ empty superstitions. They attacked literal interpretations of Scripture and accorded Christ's life the value of myth. In only two generations, the Deists had

utterly changed the face of religious life in England. As the historian Peter Gay asserts, they proved to be "powerful agents of modernity," helping to transform mankind from a "religious animal" into something quite different.

CREEDS IN VERSE

The church was deeply shaken by the attacks of the Deists, but it did not collapse. In the midst of vast ideological changes, a resurgence of evangelical piety burst from the Protestant lay population to offset temporarily the prevailing rational temper of the time. Originally a reform movement in the Church of England, evangelicalism soon made enemies of Anglican intellectuals who derisively labeled John Wesley and his band of evangelicals "Methodists" for the strict rules that governed their religious conduct. Wesley found his path diverging more and more from mainstream Anglicanism. For one thing, Methodism attracted most of its followers from the Dissenters, who gave the movement its stirring preachers and its emphasis on congregational government. Moreover, Methodism differed profoundly from all of its sources in English Protestantism. It possessed neither the narrow exclusivity of English Calvinism nor the rational formality of the Church of England. Rather, its emotional, Christ-centered piety stressed the inward assurance of salvation through good works and had much in common with the gentle, tolerant spirit of Erasmus, who had inspired a similar pietistic movement in the early Renaissance. Evangelical Protestantism helped to heal the wounds from old wars of religion and words. It crossed over national and sectarian boundaries and disseminated a profoundly personal, biblical brand of spirituality expressed in simple Christian living.

Because they spurned formal creeds and theological speculation, the evangelicals threw their energies into creating a "living" liturgy that would communicate the warmth and passion of their faith. The potency of their devotion was expressed in lay preaching, in sympathetic fellowship, and especially in fervent hymn singing. An ample vein of eighteenth-century Christmas verse streamed from the pens of gifted hymnographers such as Isaac Watts, Charles and John Wesley, and John Byrom, composers of prodigious quantities of evangelical hymns for congregational singing. Literature was not the hymnographer's chief concern. The hymns filled an important doctrinal function, for they supplied the theological backbone of the evangelical faith. John Wesley dubbed the hymns "creeds in verse," referring to their use in spreading evangelical doctrine. They may have lacked the grace and originality of first-rate religious poetry, but they were highly

successful as musical homilies and credos. They simplified and summarized Scripture with a tender concern for the common needs of people. They taught valuable lessons in practical, virtuous living. Certainly, too, they provided a much needed alternative to the doleful metrical psalms of earlier generations.

Isaac Watts's "A Cradle Hymn" (1720) was originally written for the use of children, yet it had a wide popular appeal because of its expressive, skillful exposition of biblical texts. Watts's hymn exhibits an almost familial rapport with the deity and a warm commerce with the participants in the Nativity story. Watts shares the homely piety of the medieval Franciscan, although a huge gulf yawns between them. In an age dominated by reason, the Nativity no longer figures as a sacred mystery immediately meaningful to a lay audience. Watts substitutes a human mother and child for Mary and Jesus in order to teach the congregation the proper emotional response to an event no longer automatically evocative. The mother in Watts's hymn is a pleasant, rather ordinary woman, instructing the congregation like an evangelical preacher in the daily acts of service to God:

> Mayst thou live to know and fear him,
> Trust and love him all thy days!
> Then go dwell forever near him,
> See his face, and sing his praise!

Watts and his fellow hymnographers offer smoothly versified interpretations of doctrine that outline an evangelical devotional method. John Wesley described this method as finding "clear directions for making your calling and election sure, for perfecting holiness in the fear of the Lord." Similarly, Charles Wesley, John's brother, and John Byrom use the Nativity as an emblem for personal "calling," one's assurance of personal salvation. Charles Wesley's "Hark! The Herald Angels Sing" reiterates one point regarding the Incarnation — the uplifting message of Christ's role as Savior. Wesley's hymn does not seek to elaborate that role, but merely attempts to build up an emotional understanding of redemption by incremental repetition of a single idea — the simple fact that Christ, the "newborn king," is salvation's agent:

> Mild he lays his glory by,
> Born that man no more may die,
> Born to raise the sons of earth,
> Born to give them second birth.
> Hark! the herald angels sing,
> "Glory to the newborn King!"

A CRADLE HYMN

Hush, my dear, lie still and slumber;
Holy angels guard thy bed!
Heavenly blessings without number
Gently falling on thy head.

Sleep, my babe; thy food and raiment,
House and home thy friends provide;
All without thy care or payment,
All thy wants are well supplied.

How much better thou'rt attended
Than the Son of God could be,
When from Heaven he descended,
And became a child like thee!

Soft and easy is thy cradle;
Coarse and hard thy Saviour lay,
When his birth-place was a stable,
And his softest bed was hay.

Blessed Babe! what glorious features,
Spotless fair, divinely bright!
Must he dwell with brutal creatures?
How could angels bear the sight?

Was there nothing but a manger
'Cursèd sinners could afford,
To receive the heavenly Stranger?
Did they thus affront their Lord?

Soft, my child; I did not chide thee,
Though my song might sound too hard;
'Tis thy Mother sits beside thee
And her arm shall be thy guard.

Yet to read the shameful story;
How the Jews abused their King,
How they served the Lord of Glory,
Makes me angry while I sing.

See the kinder shepherds round him,
Telling wonders from the sky;
There they sought him, there they found him,
With his Virgin-Mother by.

See the lovely Babe a-dressing,
Lovely, Infant, how he smiled!
When he wept, the Mother's blessing
Soothed and hushed the holy Child.

Lo, he slumbers in his manger,
Where the hornèd oxen fed,
Peace, my darling, here's no danger
Here's no ox anear thy bed.

'Twas to save thee, child, from dying
Save my dear from burning flame,
Bitter groans, and endless crying,
That my blest Redeemer came.

Mayst thou live to know and fear him,
Trust and love him all thy days!
Then go dwell forever near him,
See his face, and sing his praise!

I could give thee thousand kisses,
Hoping what I most desire;
Not a mother's fondest wishes
Can to greater joys aspire.

ISAAC WATTS

John Byrom's "Hymn for Christmas Day" also shows how evangelicalism can shape the content and the style of a hymn. Byrom's hymn is a perfect sermon in verse. It includes the opening invocation to the congregation to "awake" to the preacher's message; the paraphrasing of a biblical text (in this case, the angelical epiphany to the shepherds); and the final exposition and application of the text to daily life:

> Like Mary, let us ponder in our mind
> God's wondrous love in saving lost mankind:
> .
> Trace we the Babe, who has retrieved our loss,
> From the poor manger to his bitter cross;
> Treading his steps, assisted by his grace,
> Till man's first heavenly state again takes place.

In a strict literary sense, Watts and his fellow hymnographers did much to diminish the uniqueness of English devotional verse by sentimentalizing Scripture and using religious themes as conventional abstractions endorsing a multitude of everyday, unpoetical concerns. Yet it must be admitted that their object was primarily ecclesiastical, not poetic; their success in conveying simplified, memorable interpretations of biblical texts is validated by the continued popularity of their hymns. In "Joy to the World," "O Come All Ye Faithful," "God Rest Ye Merry, Gentlemen," and countless others from the "Golden Age" of Protestant hymnography still sung regularly in Protestant Christmas services, dogma has been made mellifluous and affective, while the role of the individual in interpreting the Nativity theme has been vastly expanded.

DIVINE MADMAN

The most gifted devotional poet in the eighteenth century was Christopher Smart, whose magnificent "Hymn on the Nativity" (1768) is a startling throwback to the elegant, emotionally intense lyrics of the seventeenth-century metaphysicals. Smart's work has never been given the attention worthy of his great talent, primarily because his reputation has been tarnished by his dreadful life. Readers who know the name "Kit" Smart may remember only a raving lunatic. Admittedly, his was a spectacular decline from the halls of Cambridge, where he lectured as a young man, to a madman's dank cell. Alcoholism wrecked his career as a scholar and brought misery and want to his young family. When he was barely forty, his

HARK! THE HERALD ANGELS SING

Hark! the herald angels sing,
"Glory to the newborn King;
Peace on earth, and mercy mild,
God and sinners reconciled."
Joyful, all ye nations rise,
Join the triumph of the skies;
With the angelic host proclaim,
"Christ is born in Bethlehem!"
Hark! the herald angels sing,
"Glory to the newborn King!"

Christ, by highest heaven adored,
Christ the everlasting Lord.
Late in time behold him come,
Offspring of the Virgin's womb.
Veiled in flesh the Godhead see;

Hail the incarnate Deity,
Pleased as man with men to dwell,
Jesus, our Emmanuel.
Hark! the herald angels sing,
"Glory to the newborn King!"

Hail the heaven born Prince of Peace!
Hail the Sun of righteousness!
Light and life to all he brings,
Risen with healing in his wings.
Mild he lays his glory by,
Born that man no more may die,
Born to raise the sons of earth,
Born to give them second birth.
Hark! the herald angels sing,
"Glory to the newborn King!"

CHARLES WESLEY

A HYMN FOR CHRISTMAS DAY

Christians awake, salute the happy morn
Whereon the Saviour of the world was born;
Rise, to adore the mystery of love,
Which hosts of angels chanted from above:
With them the joyful tidings first begun
Of God incarnate and the Virgin's Son.
Then to the watchful shepherds it was told,
Who heard the angelic herald's voice: "Behold!
I bring good tidings of a Saviour's birth
To you, and all the nations upon earth;
This day hath God fulfilled his promised word;
This day is born a Saviour, Christ, the Lord:

In David's city, Shepherds, ye shall find
The long foretold Redeemer of mankind;
Wrapped up in swaddling clothes, the Babe divine
Lies in a manger; this shall be your sign."
He spake, and straightway the celestial choir
In hymns of joy, unknown before, conspire.
The praises of redeeming Love they sung,
And Heaven's whole orb with Hallelujahs rung:
God's highest glory was their anthem still;
Peace upon earth, and mutual good will.
To Bethlehem straight the enlightened shepherds ran,
To see the wonder God had wrought for man;
And found, with Joseph and the blessed Maid,
Her Son, the Saviour, in a manger laid.
Amazed, the wondrous story they proclaim,
The first apostles of his infant fame.
While Mary keeps, and ponders in her heart
The heavenly vision, which the swains impart,
They to their flocks, still praising God, return,
And their glad hearts within their bosom burn.

 Let us, like these good shepherds then, employ
Our grateful voices to proclaim the joy:
Like Mary, let us ponder in our mind
God's wondrous love in saving lost mankind.
Artless, and watchful, as these favoured swains,
While virgin meekness in the heart remains,
Trace we the Babe, who has retrieved our loss,
From the poor manger to his bitter cross;
Treading his steps, assisted by his grace,
Till man's first heavenly state again takes place:
Then may we hope, the angelic thrones among,
To sing, redeemed, a glad triumphal song:
He that was born, upon this joyful day,
Around us all, his glory shall display;
Saved by his love, incessant we shall sing
Of angels, and of angel-men, the King.

<div align="right">JOHN BYROM</div>

THE NATIVITY OF OUR LORD
AND SAVIOUR JESUS CHRIST

Where is this stupendous stranger?
 Swains of Solyma advise,
Lead me to my Master's manger,
 Shew me where my Saviour lies.

O most Mighty! O most Holy!
 Far beyond the seraph's thought,
Art thou then so mean and lowly,
 As unheeded prophets taught?

O the magnitude of meekness!
 Worth from worth immortal sprung;
O the strength of infant weakness,
 If eternal is so young!

If so young and thus eternal,
 Michael tune the shepherd's reed,
Where the scenes are ever vernal.
 And the loves be love indeed!

See the God blasphemed and doubted
 In the schools of Greece and Rome,

See the powers of darkness routed,
 Taken at their utmost gloom.

Nature's decorations glisten
 Far above their usual trim;
Birds on box and laurels listen,
 As so near the cherubs hymn.

Boreas now no longer winters
 On the desolated coast;
Oaks no more are riven in splinters
 By the whirlwind and his host.

Spinks and ouzels sing sublimely
 "We too have a Saviour born";
Whiter blossoms burst untimely
 On the blest Mosaic thorn.

God all-bounteous, all creative,
 Whom no ills from good dissuade,
Is incarnate and a native
 Of the very world he made.

CHRISTOPHER SMART

alcoholic excesses had induced a religious mania, and the remaining years of his short life were spent desperately scrambling in and out of asylums. After a modest comeback as a hymnographer, misfortune descended one last time, and Smart died in debtor's prison, a sorry wreck of a man. The nasty details of his life obscure the fact that this "little, smart, black-eyed man" had a fund of genius and courage that even insanity could not kill. His two masterpieces, *Jubilato Agno* and *A Song to David*, were written in his asylum days. Yet despair never darkens their pages. Both poems are jubilant rhapsodies praising God's goodness and daring technical tours de force anticipating the mystical lyrics of Blake and the sprung rhythms of Hopkins.

In a last vain attempt to escape debtor's prison, Smart wrote a cycle of liturgical hymns from which "The Nativity of Our Lord and Saviour Jesus Christ" is taken. This is an immensely important work in an era of versified religious commonplaces, because it brings the evangelical hymn into the realm of good literature. Like other eighteenth-century hymns, Smart's hymn has an obvious moral: human virtue is made possible through Christ's birth. Yet the poem is an enormous departure from Wesley and Watts in its technical complexity and its lush diction and emotional flights. The poem is a series of incarnational paradoxes intertwined with images of natural rebirth. So brilliantly are these integrated that each paradox and each image becomes emblematic of the very process of Incarnation, that is, the deity's passage from spirit to flesh.

The "Hymn on the Nativity" moves from abstract epithets of the incarnate Christ to tangible manifestations of Christ in history, legend, and nature, ending with his birth in Bethlehem. It is the psalmist David who orchestrates these divine epiphanies: David commands the reader to "see" Christ's dawning presence among the objects and creatures in nature — in the rising of the morning star, in the magical cessation of storms, in the sudden melodic outbursts of the birds "spinks and ouzels," in the miraculous winter blooming of the Glastonbury thorn. All of these natural processes mirror the impact of the incarnate Christ on the first Christmas, while the allusions to native flora and fauna suggest, too, that Christ's mission is a continuing reality in contemporary England:

> God all-bounteous, all creative,
>> Whom no ills from good dissuade,
> Is incarnate and a native
>> Of the very world he made.

Like other evangelicals of his time, Smart views Christ as a personal friend and Savior, a kindly being worthy of the poet's heartfelt affection and praise. Yet Smart's Christ is also a magnificent abstraction, reminiscent of the heroic Christ of late Renaissance poets like Crashaw and Milton. The regal though benevolent Christ begins to resemble David, Smart's idea of the perfect man. The gifted lyrics of the poetic misfit Christopher Smart are one more step in the humanization of the Nativity theme, a process more clearly visible in the secular "nativity" lyrics of William Blake and William Wordsworth.

THE SPIRIT OF THE AGE

The great French Revolution had already been set in motion by the time a crowd of Parisian artisans stormed the Bastille in 1789. Yet middle-class men and women throughout Western Europe turned the siege into a convenient symbol for the fall of an ancient, despised, autocratic regime. In the wake of the storming of the Bastille, republicanism rippled across the continent and exploded in England, where libertarian sentiments, lately fanned by the American Revolution, had smoldered for decades. The cry "Liberty, Equality, Fraternity" was taken up by nearly all of the new crop of English writers emerging in the 1790's. Blake, Wordsworth, and Coleridge were eager adherents of a radical, innovative poetry that their contemporary William Hazlitt identified with the "revolutionary movement of our age" in his volume of penetrating essays entitled *The Spirit of the Age*. The new poets agitated for sweeping reforms of poetic rules to coincide with the mighty political ferment of the time. Their verses demolished what they felt were antiquated literary dicta bequeathed by the rule-bound followers of Dryden and Pope. Poetry, they argued, could further the aids of republicanism, and in the rough speech and homely values of the humblest of men, new poets saw the stuff of great literature. The second generation of poetic radicals, among them Shelley and Keats, was greatly disappointed by the anarchy of the French "Reign of Terror" and by the fall of France into Napoleonic despotism. Yet the disintegration of the republican dream in France did little to dampen these young poets' ardor for the still vibrant "spirit of the age." Theirs was a restless, impulsive temper, almost religiously preoccupied with the deep inner personality of the poet and with the free activity of the imagination. Later historians would label this radical shift from public to private aesthetic concerns "Romantic," giving rise to the myth of a single school of Romantic writers. Yet the so-called "Romantics" were a broad group united less by a common literary purpose than by a pervasive reformist attitude that merged talents as diverse as the prosaic Wordsworth and

the sensual Keats. The idealistic revolutionary dream died hard. After witnessing Napoleon's rise and fall, after seeing England veer sharply from libertarianism into civil repression under a Tory oligarchy in the early 1800's, Wordsworth would longingly recall the heady promise of the 1790's, when "Bliss was it in that dawn to be alive. But to be young was very heaven."

NON-CHRISTIAN NATIVITIES: THE ROMANTICS

The scriptural Nativity virtually passes out of English literature under the ascendancy of the Romantic poets, who conspicuously disavowed tradition, especially one as ancient and authoritarian as Scripture. Hazlitt observed that Wordsworth had obliterated all the conventions of past learning with one fell swoop. "We begin," said Hazlitt, "*de novo*, on a *tabula rasa* of poetry." Even so, the Nativity theme does continue, although it undergoes a curious secular transmutation in the poetry of William Blake and William Wordsworth in a way that may give the lie to the Romantics' confident claims to originality.

The French Revolution fired the imagination of the occult poet William Blake, who abandoned a promising career in engraving after being tried and acquitted for sedition. His unhappy brush with the political authorities made him determined to follow a "Divine Vision," and he took up the solitary, impecunious existence of a poet-illustrator. Blake's lack of success while he lived can be attributed to his bizarre, oracular poetry, which was shaped by an esoteric private mythology. Yet although he was considered wildly eccentric by his contemporaries, today Blake is among the most widely-read English poets.

His iconoclastic use of the Nativity sets an important precedent for modern Nativity poems. He is the first poet to treat the theme wholly independent of church doctrine, an approach that many twentieth-century religious poets share with Blake. Christ becomes a secular, ambivalent figure appearing in various disguises throughout Blake's verse. Most enigmatic is the image of the Christ child as lamb or human infant, prominent characters in the pastoral *Songs of Innocence* (1789), Blake's first important work. These "songs" deal directly with human childhood in an idealized rural setting, and the Christian Nativity provides only a secondary frame of reference enriching and complicating the poem's naturalism.

One need not accept Thomas Altizer's view of Blake as the "first Christian atheist" to notice the sensuality of Blake's Nativity allusions. Blake uses metaphors like the lamb, the garden, and the human child, fully cognizant of their conventional Nativity associations. To the poet, however, these religious motifs have a carnal

aspect as well. In "The Lamb," both child and lamb are Christlike in their innocence, but totally distinct from the Godhead:

> Little Lamb, who made thee?
> Dost thou know who made thee?

Blake's accompanying illustrations with their rich fleshly tints and intertwining marginal vegetation intensify the erotic content of the poem. Picture goes hand in hand with poem, for Blake saw them fused into an integral design.

"A Cradle Song" resembles Watts's "A Cradle Hymn" in that both attempt to humanize the Nativity. Watts, however, shows the distinction between Christ and a human child by using logical, clear language, whereas Blake celebrates an idealized human infant by using incantatory, emotive language. Christ does not appear in person in Blake's secular "nativity" lullaby. Christ has shrunk to a shadow flitting across the face of a real infant while a vague, unrealized maternal anxiety mounts gradually in the poem. In imitation of the Virgin, an earthly mother croons to her babe on the happy Christmas eve when "all creation slept and smiled." Inexplicably, however, her joy turns to sorrow as if she were reflecting the "smiles and tears" of her child's unpredictable "maker":

> Sweet babe, in thy face
> Holy image I can trace.
> Sweet babe, once like thee,
> Thy maker lay and wept for me.

The massive, imposing human mother in "A Cradle Song's" accompanying illustration suggests Blake's ambivalent view of the Christian Incarnation. This ambivalence is made explicit in a pessimistic companion piece to "A Cradle Song" from Blake's second, darker cycle of lyrics, *Songs of Experience* (1794). The second lullaby substitutes for "holy image" the more sinister "soft desires, secret joys and secret wiles" passing over the infant's visage. The human mother of this lullaby of "experience" discovers in fascination and fear the first evidence of concupiscence in her tiny son. These innate traces of vice point to a future, cosmic disorder, in contrast to the saintly human infant of Blake's earlier, more "innocent" lullaby in which the infant's humanity was justified by references to the self-sacrificing Christ child:

> O the cunning wiles that creep
> In thy little heart asleep.
> When thy little heart does wake,
> Then the dreadful lightnings break.

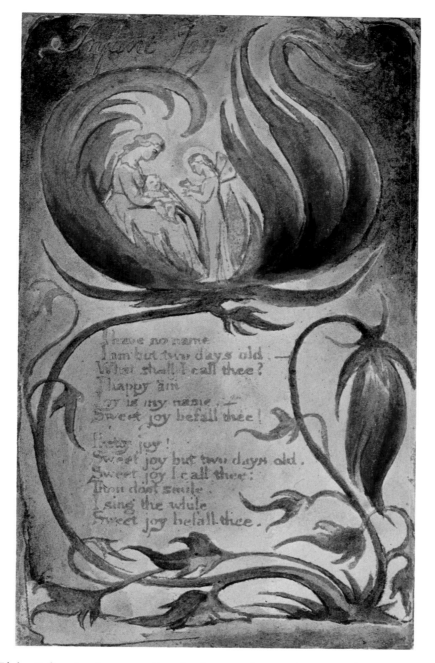

Plate 17. *William Blake,* Infant Joy *(copper etching, hand colored, from* Songs of Innocence, *1789)*
Blake's art and poetry use many of the elements common to the Nativity theme, but in a secularized and wholly per- *sonal way. The rich, vegetative border intertwines poem and illustration in a single organic unit. Rosenwald Collection, Library of Congress*

THE LAMB

Little Lamb, who made thee?
Dost thou know who made thee?
Gave thee life & bid thee feed,
By the stream & o'er the mead;
Gave thee clothing of delight,
Softest clothing wooly bright;
Gave thee such a tender voice,
Making all the vales rejoice!
Little Lamb who made thee?
Dost thou know who made thee?

Little Lamb I'll tell thee,
Little Lamb I'll tell thee!
He is callèd by thy name,
For he calls himself a Lamb:
He is meek & he is mild,
He became a little child:
I a child & thou a lamb,
We are callèd by his name.
Little Lamb God bless thee.
Little Lamb God bless thee.

WILLIAM BLAKE

A CRADLE SONG

Sweet dreams, form a shade
O'er my lovely infant's head;
Sweet dreams of pleasant streams
By happy, silent, moony beams.

Sweet sleep, with soft down
Weave thy brows an infant crown.
Sweet sleep, Angel mild,
Hover o'er my happy child.

Sweet smiles, in the night
Hover over my delight;
Sweet smiles, Mother's smiles,
All the livelong night beguiles.

Sweet moans, dovelike sighs,
Chase not slumber from thy eyes.
Sweet moans, sweeter smiles,
All the dovelike moans beguiles.

Sleep, sleep, happy child,
All creation slept and smil'd;
Sleep, sleep, happy sleep,
While o'er thee thy mother weep.

Sweet babe, in thy face
Holy image I can trace.
Sweet babe, once like thee,
Thy maker lay and wept for me.

Wept for me, for thee, for all,
When he was an infant small
Thou his image ever see,
Heavenly face that smiles on thee.

Smiles on thee, on me, on all;
Who became an infant small.
Infant smiles are his own smiles;
Heaven & earth to peace beguiles.

WILLIAM BLAKE

Blake's "Songs" are not the only Romantic poems to reshape Nativity motifs into secular form. William Wordsworth's "Ode: Intimations of Immortality" (1802–1804) makes no mention of the Christian Nativity and is hence not a Nativity poem in the strict thematic sense. However, any collection of Nativity poems would be incomplete without a brief mention of the "Ode," for it offers the most extreme nonreligious view of the Nativity in English verse. Whereas medieval and Renaissance poets used Christ's life as the ideal measure for human virtue, Wordsworth deifies his own life. Wordsworth's primary metaphor for holiness is his own birth, the event where commerce with a preexistent state of bliss is easiest. But Wordsworth's celebration of human childhood is accompanied by profound anxiety. The Christian Nativity poem yearns for the fulfillment of history in Christ, since birth and death bring about redemption. By contrast, Wordsworth expresses in the "Ode" a discomforting nostalgia, an acute fear of time lost. Nor does the poem linger reassuringly upon the poet's visionary moments of remembered childhood divinity; the poet must content himself with the fragile memory of "primal sympathy" to sustain him in his dotage:

> What though the radiance which was once so bright
> Be now forever taken from my sight,
> Though nothing can bring back the hour
> Of splendor in the grass, of glory in the flower;
> We will grieve not, rather find
> Strength in what remains behind;
> In the primal sympathy
> Which having been must ever be;
> In the soothing thoughts that spring
> Out of human suffering;
> In the faith that looks through death,
> In years that bring the philosophic mind.

Without the person of the incarnate Christ in whom nature's renewal and man's redemption are symbolically reenacted, the Romantic poet searches but cannot find a comforting exit from a life dominated by what Wordsworth calls "shades of the charnel house."

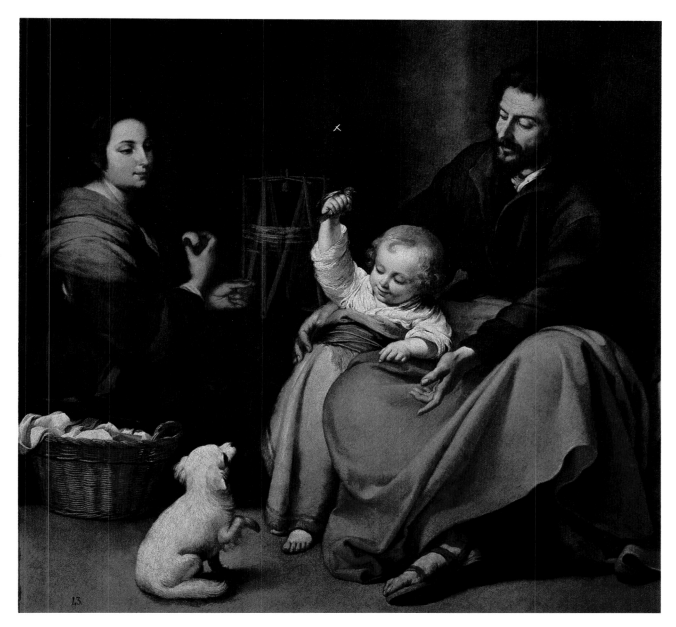

Plate 18. *Bartolomé Esteban Murillo,* Sacred Family *(mid-seventeenth cent.)*
The seventeenth-century Murillo presents a scene that both Romantics and Victorians would understand in the nineteenth century: although the title calls this the "sacred" family, the *painting is devoid of religious symbolism. The Nativity is being domesticated and secularized; the sacred family could be any congenial middle-class family. Prado, Madrid (Scala, New York / Florence)*

VICTORIAN ORTHODOXY

Under Queen Victoria, England reached an apex of power and prestige. Early industrial gains had transformed the peaceful English countryside into a patchwork of smoky factory towns and busy cities crisscrossed by canals, roads, and railways teeming with commercial traffic. The heart of English industry was the grimy Midlands, which earned its reputation as the "Workshop of the World" by putting its women and children to work. By the 1870's, England had become the financial capital of the world. Victoria had inherited from her Hanoverian uncles an immense empire "on which the sun never set." It stretched from the coast of Canada to the West Indies, down to New Zealand and to the colonies ringing the coast of Africa. Of all the empire's rich domains, India was the richest. England sported this "so rare jewel in the Crown" as proudly as Victoria wore on her ample bodice the stunning, golden Koh-i-noor diamond, a maharaja's "Mountain of Light," big as a hen's egg.

The prosperous Victorian middle class saw the ascendancy of the British Empire as the glorious fulfillment of hard work and respectable living. It is this pervasive bourgeois temper — with its evangelical earnestness, its zeal for reform, its overwhelming confidence in material progress — that characterizes for most people the monarch as well as her age. In truth, the age of Victoria was one of astounding turbulence and complexity, especially in matters of faith. Rapid progress in science was accompanied by conservative religious trends within the Church of England such as the Oxford Movement, led by Anglican reformers seeking to embrace some measure of Catholic ritual and traditions. Swinburne's pagan sensuality was diametrically opposed to Tennyson's rectitude. Jane Austen's decorum was the antithesis of George Eliot's rebellion. On the floor of Parliament and on the streets of London, political conservative came face to face with rabid social reformer.

The intellectual ferment originally unleashed by the bourgeois in the early years of Victoria's reign swelled as the century waned. The scientific theories of Darwin and Lyell and the revolutionary economic treatises of Marx and Engels sent a spasm of horror through the pious. The bulwarks of Christianity — the creation of man, the immortality of the soul, even the existence of God — had been relegated by scientists to the status of folklore. The so-called smugness and conservativism of late Victorian orthodoxy in reality often masked an anguished perplexity and a longing for the liberal dreams of a not-too-distant past.

VICTORIAN ICONOCLASTS

Having been raised with the practical, evangelical pieties of the Wesleys, most Victorian bourgeois venerated Christmas for the domestic values it encouraged. Christmas provided a joyous occasion for renewing the humanities that anchored the security-conscious middle class to the bedrock of family, church, and kingdom. The identification of Christmas with warm fellowship is eloquently explored by Charles Dickens in *A Christmas Carol*, where the social misfit Scrooge is initiated into the brotherhood of common humanity by Tiny Tim, the valiant crippled boy. In his novel, Dickens has submerged the scriptural Nativity into a pious, secular allegory of human kinship and charity in which a suffering, idealized child figures prominently.

It remains for the most iconoclastic of Victorian intellectuals, the poets associated with the Pre-Raphaelite brotherhood, to spearhead a modest revival of the scriptural Nativity theme, accompanied by the medieval motifs that Victorian evangelicals had largely ignored. The Pre-Raphaelites were motivated in part by the rage among antiquarians for archaic literature. The 192 medieval ballads or "reliques" first discovered in manuscript and ruthlessly doctored by Bishop Thomas Percy in 1765 were reissued in their original, unexpurgated form in 1867 and met wide popular acclaim. Percy's new, authenticated *Reliques* was followed by a host of glossy anthologies of Christmas carols, ballads, and hymns, containing long-neglected Nativity poems from the past. Victorians delighted over W. H. Husk's *Songs of the Nativity*, A. H. Bullen's *A Christmas-Garland, Carols and Poems from the Fifteenth Century to the Present*, William Sandys's *Christmas Carols, Ancient and Modern*, H. C. Beeching's *A Book of Christmas Verse*. These and other nineteenth-century "carol" collections mined an ancient religious literary tradition for medieval and Renaissance Nativity songs and lyrics that seemed quaint and exotic to Victorian eyes. In light of the Victorians' thirst for exotica, the Pre-Raphaelites' romantic attachment to the Middle Ages was partly a desire to escape the convulsive, inadequate present. The two chief examples of Pre-Raphaelite Nativity verse, Algernon Charles Swinburne's "Three Damsels in the Queen's Chamber" and Christina Georgina Rossetti's "A Christmas Carol," avoid Tennysonian moralizing for straight story telling. The story told is the scriptural Nativity, yet both poets combine tradition with startlingly original insights. Swinburne and Rossetti were intimates of the rebellious tribe of aesthetes led by Christina's brother, the poet-painter Dante Gabriel Rossetti. They shared the Pre-Raphaelite's love of archaic themes and poetic forms, lush language, and melancholy dreaminess.

However, they represent opposing poles within the brotherhood. Swinburne championed atheism and debauchery, while the beautiful, nunlike Christina chose not to marry and led a life of intense devotion.

Ironically, it is Swinburne, the enfant terrible of Victorian England, who first retrieves past traditions in Nativity verse and restores an aura of mystery to the now hackneyed theme. Swinburne hypnotizes the reader with his dreamlike rendition of the Apocryphal tale of Joseph's jealousy, familiar in medieval drama and old ballads like the "Cherry Tree Carol." Yet Swinburne totally ignores doctrine. His ballad, "Three Damsels in the Queen's Chamber," recasts the legend into a titillating narration of sexual betrayal in the holy family by imposing a haunting, pseudochivalric framework on the ancient story. Mary's and Joseph's estrangement is related by a licentious queen resembling two adulterous beauties of yore, Guinevere and Mary, Queen of Scots (who also had several "Maries" as handmaidens). Lacking the religious ballad's ethical point of view, the ancient joke of Mary's suspected infidelity takes on a contemporary amorality. As described by the languid queen, Mary's swelling belly suggests an extramarital liaison. Mary herself is a woman of compelling, unabashed sensuality, and in this she becomes indistinguishable from the fair queen and the handmaidens. With great technical virtuosity, Swinburne unites familiar characters and events from the gospel Nativity chronicles with a refrain invoking a disturbingly erotic Mary:

> When she sat at Joseph's hand,
> She looked against her side;
> And either way from the short silk band
> Her girdle was all wried.
> Mary that all good may,
> Bring us to thy Son's way.

Where Swinburne is sensual, Rossetti is devout. Although Rossetti's "A Christmas Carol" shares the same romantically medieval atmosphere as Swinburne's poem, her "carol" is the antithesis of Swinburne's amoral ballad in terms of religious content. "A Christmas Carol" reflects the Anglo-Catholicism of its author, whose melancholy, otherworldly poems made her the most popular Christian poet in Victorian England. Her asceticism was not of the masses, however. It set her apart from her rebellious brother and led her to spurn two offers of marriage, both to men she loved. She closed the door on the domestic security so prized by the Victorian middle class, although her poetry often reveals her anguish at relinquishing earthly for divine love. As her reclusive life serves to

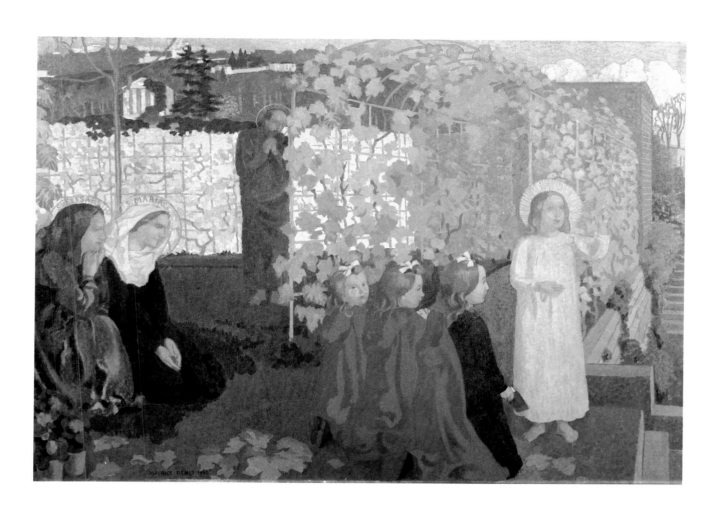

Plate 19. *Maurice Denis,* Nazareth *(1905)*
Denis adapted the Nativity theme to the techniques of late nineteenth-century painting much as Swinburne adapted the Nativity to his distinctive poetic style. Denis, however, is much the more sincere in his treatment of the religious subject matter. Collection of Modern Religious Art, Vatican City (Scala, New York/Florence)

A CHRISTMAS CAROL

Three damsels in the queen's chamber,
 The queen's mouth was most fair;
She spake a word of God's mother
 As the combs went in her hair.
 Mary that is of might
 Bring us to thy Son's sight.

They held the gold combs out from her
 A span's length off her head:
She sang this song of God's mother
 And of her bearing-bed.
 Mary most full of grace,
 Bring us to thy Son's face.

When she sat at Joseph's hand,
 She looked against her side;
And either way from the short silk band
 Her girdle was all wried.
 Mary that all good may,
 Bring us to thy Son's way.

Mary had three women for her bed:
 And twain were maidens clean;
The first of them had white and red,
 The third had riven green.
 Mary that is so sweet,
 Bring us to thy Son's feet.

She had three women for her hair:
 Two were gloved soft and shod;
The third had feet and fingers bare,
 She was the likest God.
 Mary that wieldeth land,
 Bring us to thy Son's hand.

She had three women for her ease:
 The twain were good women;
The first two were the two Maries,
 The third was Magdalen.
 Mary that perfect is,
 Bring us to thy Son's kiss.

Joseph had three workmen in his stall,
 To serve him well upon;
The first of them were Peter and Paul,
 The third of them was John.
 Mary, God's handmaiden,
 Bring us to thy Son's ken.

"If your child be none other man's,
 But if it be very mine,
The bedstead shall be gold two span,
 The bed-foot silver fine."
 Mary that made God mirth,
 Bring us to thy Son's birth.

"If the child be some other man's,
 And if it be none of mine,
The manger shall be straw two spans,
 Betwixen kine and kine."
 Mary that made sin cease,
 Bring us to thy Son's peace.

Christ was born upon this wise,
 It fell on such a night,
Neither with sounds of psalteries,
 Nor with fire for light.
 Mary that is God's spouse,
 Bring us to thy Son's house.

The star that came out upon the east
　With a great sound and sweet;
Kings gave gold to make him feast
　And myrrh for him to eat.
　　Mary, of thy sweet mood,
　　Bring us to thy Son's good.

He had two handmaids at his head,
　One handmaid at his feet;
The twain of them were fair and red,
　The third one was right sweet.
　　Mary that is most wise,
　　Bring us to thy Son's eyes. Amen.

ALGERNON CHARLES SWINBURNE

A CHRISTMAS CAROL

In the bleak mid-winter
　Frosty wind made moan,
Earth stood hard as iron,
　Water like a stone;
Snow had fallen, snow on snow,
　Snow on snow,
In the bleak mid-winter
　Long ago.

Our God, Heaven cannot hold him,
　Nor earth sustain;
Heaven and earth shall flee away
　When he comes to reign:
In the bleak mid-winter
　A stable-placed sufficed
The Lord God Almighty
　Jesus Christ.

Enough for him whom cherubim
　Worship night and day.
A breastful of milk
　And a mangerful of hay;

Enough for him whom angels
　Fall down before,
The ox and ass and camel
　Which adore.

Angels and archangels
　May have gathered there,
Cherubim and seraphim
　Thronged the air,
But only his mother
　In her maiden bliss
Worshipped the Beloved
　With a kiss.

What can I give him,
　Poor as I am?
If I were a shepherd
　I would bring a lamb,
If I were a wise man
　I would do my part, —
Yet what I can I give him,
　Give my heart.

CHRISTINA ROSSETTI

illustrate, Rossetti was part of the return to a Catholic style of spirituality in the Anglican church. Rossetti's "carol" retrieves the sweetness and spontaneity of the medieval Catholic Nativity lullaby in its refreshing simplicity, its denial of sentimental evangelicalism for a mystical celebration of church symbol and sacrament. Clearly, Rossetti attempted an artful rendition of the medieval carol's naive spirit without imitating its strict stanza-burden form. She uses short, elliptical phrases and reduces the rhythm of the last line by one beat to suggest a refrain. Like a medieval Franciscan, she scrupulously outlines the physical details of the gospel Nativity and revives commonplace medieval motifs such as the winter setting and the penitent's approach to the crèche. Coming at the end of the Victorian era when such heartfelt adoration of Christ was almost nonexistent, Rossetti's "carol" emerges as a poignant work attesting to a lonely woman's abiding devotion to an ancient, nearly worn-out religious symbol:

> What can I give him,
> Poor as I am?
> If I were a shepherd
> I would bring a lamb,
> If I were a wise man
> I would do my part, —
> Yet what I can I give him,
> Give my heart.

Plate 20. *William Adolphe Bouguereau,* Mother and Child *(1879)*
Bouguereau's work, though highly derivative and formulaic, was nevertheless very popular among the middle classes of nineteenth-century France and England. This painting is patterned after a work by Raphael; its sentimental sweetness appealed in a maudlin way to the same emotions that Christina Rossetti's poetry appealed to with greater artistic integrity. The Cleveland Museum of Art (the Hinman B. Hurlbut Collection)

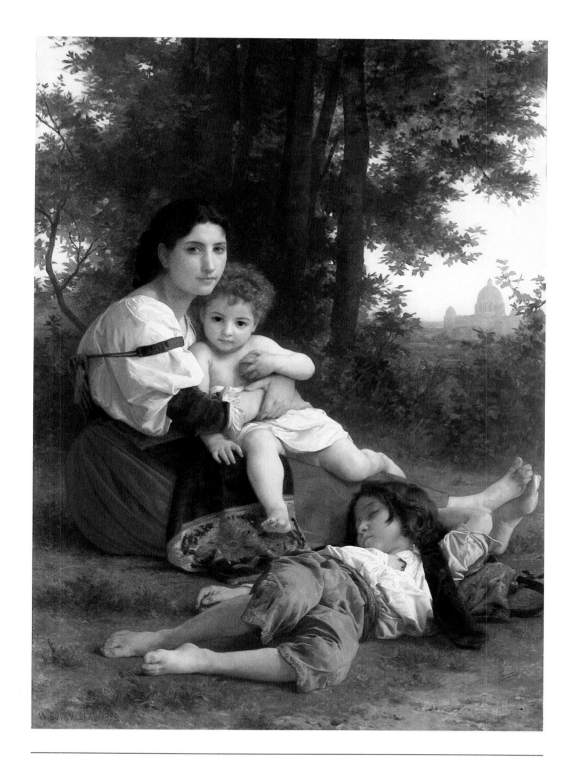

V Swaddled with Darkness

THE TWENTIETH CENTURY

MANKIND ALONE

IN T. S. Eliot's "Gerontion" (1919), an old blind man contemplates the windy spaces of history and wonders why the great promise of the Incarnation remains dumb and hidden in shadow:

> The word within a word, unable to speak a word,
> Swaddled with darkness.

In 1919, Eliot saw his youthful malaise mirrored in the plight of the aged Gerontion, sitting speechless and sightless amidst the detritus of European civilization left after the Great War. Yet spiritual blindness was not Gerontion's and Eliot's alone. It was a generational affliction, falling suddenly and shatteringly on the young men and women of the 1920's who saw the old norms of civilization wiped away by the brutality of the First World War. With all sense of order lost, the need to recapture even an apparent sense of order became a dominant literary concern in Eliot's time. Eliot himself sought order in religion as well as in art. His later commitment to Anglo-Catholicism was a conscious effort to regain the fragmented image of Jesus that haunted earlier lyrics like "Gerontion." Still, it is the issue of religious doubt raised by Eliot, rather than its solution, that touches his twentieth-century readers most profoundly. This is understandable, for events since World War I have only caused that doubt to deepen and to spread from a generalized attitude in Eliot's era to an existential uneasiness that sits heavily on the psyches of the most ordinary men and women today. Since "Gerontion," we have witnessed another global war, the threat of nuclear holocaust, frantic cycles of prosperity and recession, an insidious mushrooming of technocracies and bureaucracies. Small wonder that people have become increasingly drawn in the last years to exploring the "safer" realm of private, unconscious experience. Small wonder that, to a skeptical age cut off from a past literary tradition closely tied to the Bible, the image of Christ in literature has grown increasingly dim. The

poet W. H. Auden, in the verse play *The Age of Anxiety* (1947), characterizes Christ by his absence from human history. Christ is an elusive, capricious,

> semi-divine stranger with superhuman powers, some Gilgamesh or Napoleon, some Solon or Sherlock Holmes, appearing from time to time to rescue [man and nature] from their egregious destructive blunders.

Despite the disillusionment in this century with traditional spiritual mores, a revitalized religious consciousness has emerged among contemporary Christian theologians and poets. In the early years of the century, theologians Albert Schweitzer and Rudolf Bultmann attempted to discover the "historic" Jesus, demythologized and purged of the mists of superstition. Major poets on both sides of the Atlantic have similarly sought the "real" Jesus by seizing upon the ancient scriptural theme of Christ's life as a new poetic myth for an age divided from its spiritual past. The Nativity theme makes a startling reentry into the mainstream of English poetry at the turn of the century after two hundred years of literary disfavor, and surfaces in the leading schools of American verse after World War II as well. The theme, however, never achieves the cultural centrality that it enjoyed in the Renaissance. Perhaps this is because the twentieth-century poet writing on the Nativity faces an enormously difficult task. He must confront an audience for whom the old Christian symbols are no longer unanimously understood nor accepted. He now speaks as a solitary individual using signs that may not be recognizable to people of varying religious persuasions. The poet also confronts the fact that Christianity is of international scope, having absorbed many non-Western traditions as it once did pagan customs in Anglo-Saxon England. Nor is Christianity the central tradition of the Western world as it had been in former centuries. It must contend with and accommodate secular philosophies such as Marxism, Freudianism, and existentialism, which have risen to challenge Christianity's former hold over culture and thought.

The poet writing on the Nativity belongs to a contemporary breed of literary artist. He is often skeptical, alienated from the main historical formulations of faith, uncomfortable with the old Bible stories. He lacks the medieval *clerc*'s joy, the Renaissance poet's sublimity, the quiet assurance of Hopkins or Rossetti. Often, the poet using devotional themes may not be a *dévot* himself. To the nonbeliever William Butler Yeats, the impending birth of Christ is little cause for joy. In Yeats's "The Mother of God" (1932), Mary is filled with a profound dread,

> The terror of all terrors that I bore
> The Heavens in my womb.

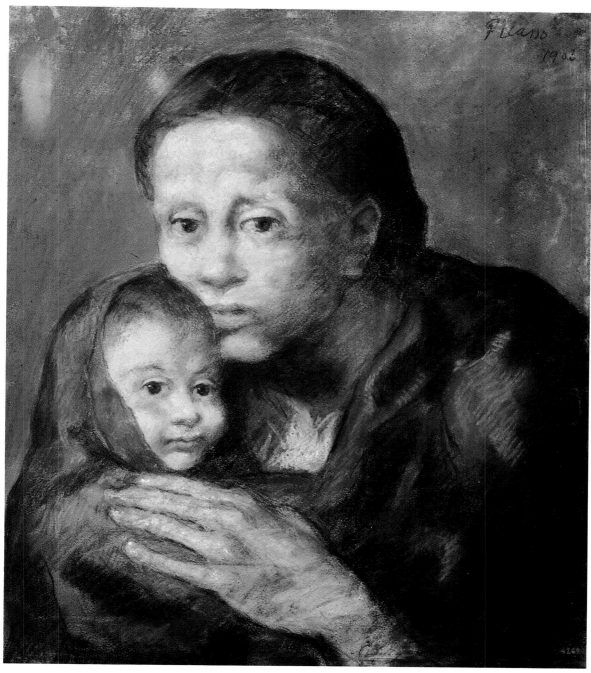

Plate 21. *Pablo Picasso,* Donna con Bambino *(1902)* *In the twentieth century, the conventional Madonna and Child is more often simply a mother and child. One of Picasso's early works, this painting reveals an anxious, sol-itary, haunted mother —far removed from the demure and adoring Madonnas of earlier centuries. Picasso Museum, Barcelona (Scala, New York/Florence)*

Yet a large measure of traditional devotion persists in most twentieth-century Nativity poems, despite the fact that they reflect the deeply personal nature of religious faith today and the private tensions that drive the modern poet to pursue his craft. In "Lullaby," Edith Sitwell uses the medieval lullaby form to rage against the mindless violence in London during Hitler's blitzkrieg. Eliot returns to the birth narratives of Matthew and Luke in "Journey of the Magi" to bemoan the aridity and enervation of a civilization that the poet sees hovering on the edge of transformation. W. H. Auden employs the episodic structure of the medieval mystery play to restore to the theme a bit of its former grandeur while exploring the modern existential issues of responsibility and freedom. To Lawrence Ferlinghetti, the Nativity is an impossible yet yearned-for occurrence in a materialistic world. The contemporary poet challenges his reader with a self-made Nativity myth, throwing his poem like a gauntlet before an audience bereft of universal religious absolutes.

THE CENTER CANNOT HOLD

Gazing dispassionately over the heads of curious museumgoers, two sepulchral statues stand locked in their own universe. The celebrated English sculptor Jacob Epstein shaped a Virgin and child devoid of compassion in his stark composition "Madonna and Child for Cavendish Square" (1952). The focus of the sculpture is the child Jesus, an otherworldly figure with an awesome foreboding in his face. Clearly this is not the sweet infant of gospel tradition, but the risen, judgmental Christ of the Apocalypse, associated in the Book of Revelation with retribution and death. His swaddling bands cling along thin, cadaverous limbs like a winding sheet; his arms are raised stiffly in the attitude of the Passion. Epstein places before our eyes the frightening figure of a martyred holy infant who enters history like a scourge of God.

If a tonic chord persists among twentieth-century Nativity poems, it is Epstein's view of the Nativity as apocalypse, as an ominous symbol of civilization's decay. The literary source for this macabre view of Christ's birth is the Irish poet William Butler Yeats, whose secular "nativity" poems, "The Magi" (1914) and "The Second Coming" (1916), arise out of Yeats's searing memories of rebellion and war and out of his grim belief that history was rapidly proceeding to a terrible moment of reckoning:

> Things fall apart; the center cannot hold;
> Mere anarchy is loosed upon the world,

The blood-dimmed tide is loosed, and everywhere
The ceremony of innocence is drowned.

Yeats, the enemy of Christian orthodoxy, confessed that the "pale, unsatisfied ones" in "The Magi" owe less to doctrine than to the operation of his own unconscious, for the poem sprang unbidden to mind one day when "lost in the blue of the sky." In *A Vision*, Yeats's prose exposition of his view of the cosmos, the magi are said to represent "the rigid world of law and custom," a world trapped in an eternity of repression. The eminent critic Harold Bloom further labels the magi "Yeats's war gods," imaginary creatures prophesying a deadly release of animal instinct. For Yeats, the Christian Nativity ironically suggests a violent commencement of an anarchic age. In "The Magi," this new era is spawned by a nameless "uncontrollable mystery on the bestial floor."

The most famous and controversial allusion to the Nativity occurs in "The Second Coming," which the poet revised in 1919 in the wake of the Great War and revolutionary tyrannies. Yeats's particularly hostile stance against the Russian revolution gives the poem an uncommon, bloody perspective on human history. In "The Second Coming," history is seen as a series of interlocking "gyres" or conical cycles hurtling toward a cleansing devastation. Yet despite decades of scholarly scrutiny, the poem remains cloaked in ambiguity. Readers simply cannot agree on the poem's use or dismissal of Christian symbols. There is good evidence, however, that Yeats himself intended this non-Christian view of history to relate to the Christian Nativity and Second Coming. It is certainly possible to see a demonic parody of divine birth in the antireligious Nativity of the lumbering sphinx "slouching to Bethlehem" to set in motion a cycle of lawlessness and despair:

The darkness drops again; but now I know
That twenty centuries of stony sleep
Were vexed to nightmare by a rocking cradle,
And what rough beast, its hour come round at last,
Slouches towards Bethlehem to be born?

THE MAGI

Now as at all times I can see in the mind's eye,
In their stiff, painted clothes, the pale unsatisfied ones
Appear and disappear in the blue depth of the sky
With all their ancient faces like rain-beaten stones,
And all their helms of silver hovering side by side,
And all their eyes still fixed, hoping to find once more,
Being by Calvary's turbulence unsatisfied,
The uncontrollable mystery on the bestial floor.

<div align="right">WILLIAM BUTLER YEATS</div>

THE MOTHER OF GOD

The threefold terror of love; a fallen flare
Through the hollow of an ear;
Wings beating about the room;
The terror of all terrors that I bore
The Heavens in my womb.

Had I not found content among the shows
Every common woman knows,
Chimney corner, garden walk,
Or rocky cistern where we tread the clothes
And gather all the talk?

What is this flesh I purchased with my pains,
This fallen star my milk sustains,
This love that makes my heart's blood stop
Or strikes a sudden chill into my bones
And bids my hair stand up?

<div align="right">WILLIAM BUTLER YEATS</div>

THE SECOND COMING

Turning and turning in the widening gyre
The falcon cannot hear the falconer;
Things fall apart; the center cannot hold;
Mere anarchy is loosed upon the world,
The blood-dimmed tide is loosed, and everywhere
The ceremony of innocence is drowned;
The best lack all conviction, while the worst
Are full of passionate intensity.

Surely some revelation is at hand;
Surely the Second Coming is at hand.
The Second Coming! Hardly are those words out
When a vast image out of *Spiritus Mundi*
Troubles my sight: somewhere in sands of the desert
A shape with lion body and the head of a man,
A gaze blank and pitiless as the sun,
Is moving its slow thighs, while all about it
Reel shadows of the indignant desert birds.
The darkness drops again; but now I know
That twenty centuries of stony sleep
Were vexed to nightmare by a rocking cradle,
And what rough beast, its hour come round at last,
Slouches towards Bethlehem to be born?

WILLIAM BUTLER YEATS

THE SOUNDLESS WAILING

The First World War casts a long shadow over the earlier poems of T. S. Eliot, the great poet of the 1920's. That shadow fell on all those of Eliot's generation who fought a grim *rite de passage* in the bloody trenches that stretched from the coast of Flanders to the cliffs beyond Cape Helles. After the smoke cleared from the battlefields, the death toll on both sides was a staggering ten million. In a sense, the survivors were far less lucky than their dead comrades, for they bore insidious psychic scars. Ypres. Gallipoli. The Somme. Out of the carnage emerged a generation of lost souls bitterly repudiating what they felt were the pretensions and false values of an older, gentler age. Many followed Eliot's fellow midwesterners F. Scott Fitzgerald and Ernest Hemingway into a desperate nihilism. Eliot himself carved out a more solitary path. After a period of scathing cynicism, he turned back to what his essay on Dante calls "a coherent traditional system of dogma and morals." The brilliant young poet of *The Waste Land* (1922) who paints an unforgettable picture of sterile modern civilization also gives us in his maturity *Ash Wednesday* (1930) and *Four Quartets* (1935–1942), poems of penitence and hope. The Incarnation is a recurrent motif in Eliot's religious verse, emerging as a modern myth of man's postwar alienation from the divine.

The most memorable use of the Nativity is Eliot's "Journey of the Magi" (1927), one of four "Ariel" poems published by Faber and Faber between 1927 and 1931 in a series of Christmas verse. In this early devotional work, the poet's personal search for religious stability in a disordered world is mirrored in the plight of the magus. Clearly, this is not the dignified wise man of medieval and Renaissance legend, the lordly figure bearing rich gifts. His is a supremely modern intelligence, able to decipher with a scientific precision the physical details of the landscape through which he has passed. Yet his quest to find the infant has been a wearisome, puzzling trial. The splendor of this great mystery has left him unmoved. Nor can he explain why the birth was "hard" and tinged with death, for he has no foreknowledge of the Passion. His disturbing glimpse into a mystery impenetrable to human wisdom has left him estranged from his time and his people, and longing for release in his own death. He has recognized the validity of this strange, otherworldly birth, but he is still locked in the old order that the revelation of Christ will soon sweep away:

> We returned to our places, these Kingdoms,
> But no longer at ease here, in the old dispensation,
> With an alien people clutching their gods.
> I should be glad of another death.

Eliot's own journey from skepticism to conservative Anglicanism made him as much a stranger in his age as the magus. Yet this testy traditionalism also gave Eliot a unique platform as a literary and social critic. His 1939 Cambridge lectures, entitled *The Idea of a Christian Society*, called for a nation dominated by a "community of Christians" under whose guidance a common culture would once more arise. The notion of a society governed by Christian precepts constitutes a powerful alternative to what Eliot saw as the rise of "paganism" in a nation suffering internally from moral breakdown and threatened externally by rising Fascist states.

The religious convictions Eliot explores in his Cambridge lectures are given remarkably sustained and moving elaboration in *Four Quartets*, an ambitious work that very nearly transcends the despairing vision of most twentieth-century religious poets. Throughout the *Quartets*, traditional religious formulae are invested with a contemporary relevance. The laconic narrator possesses an old-fashioned piety as well as the guilt-ridden, uneasy faith of a secular age. Central to the poem is the Incarnation, which to the poet illuminates man's painful attempts to penetrate the eternal plane lying above and through human time. In the section entitled "Dry Salvages," the endless, empty progression of unredeemed human time is captured in the bleak image of "soundless wailing":

> Where is there an end of it, the soundless wailing,
> The silent withering of autumn flowers
> Dropping their petals and remaining motionless?

Yet the "Dry Salvages" represents a considerable advancement in religious optimism over the blind old Gerontion's imperviousness to the "word within a word, unable to speak a word." The image of "soundless wailing" suggests a slightly more hopeful interpretation of the Incarnation than the arid silence of unregenerate history in "Gerontion." In the final section of "Dry Salvages," the image recalls the fruitful, primordial language of the *Verbum infans*, the inarticulate, incarnate Word of church tradition in whom the discordant rhythms of the eternal and the temporal meet in perfect harmony:

> The hint half guessed, the gift
> half understood, is Incarnation.
> Here the impossible union
> Of spheres of existence is actual,
> Here the past and future
> Are conquered, and reconciled.

GERONTION

Thou hast nor youth nor age
But as it were an after dinner sleep
Dreaming of both.

Here I am, an old man in a dry month,
Being read to by a boy, waiting for rain.
I was neither at the hot gates
Nor fought in the warm rain
Nor knee deep in the salt marsh, heaving a cutlass,
Bitten by flies, fought.
My house is a decayed house,
And the Jew squats on the window sill, the owner,
Spawned in some estaminet of Antwerp,
Blistered in Brussels, patched and peeled in London.
The goat coughs at night in the field overhead;
Rocks, moss, stonecrop, iron, merds.
The woman keeps the kitchen, makes tea,
Sneezes at evening, poking the peevish gutter.
 I an old man,
A dull head among windy spaces.

 Signs are taken for wonders. "We would see a sign!"
The word within a word, unable to speak a word,
Swaddled with darkness. In the juvescence of the year
Came Christ the tiger

 In depraved May, dogwood and chestnut,
 flowering judas,
To be eaten, to be divided, to be drunk
Among whispers; by Mr. Silvero
With caressing hands, at Limoges
Who walked all night in the next room;

By Hakagawa, bowing among the Titians;
By Madame de Tornquist, in the dark room
Shifting the candles; Fräulein von Kulp
Who turned in the hall, one hand on the door.
 Vacant shuttles
Weave the wind. I have no ghosts,
An old man in a draughty house
Under a windy knob.

 After such knowledge, what forgiveness? Think now
History has many cunning passages, contrived corridors
And issues, deceives with whispering ambitions,
Guides us by vanities. Think now
She gives when our attention is distracted
And what she gives, gives with such supple confusions
That the giving famishes the craving. Gives too late
What's not believed in, or if still believed,
In memory only, reconsidered passion. Gives too soon
Into weak hands, what's thought can be dispensed with
Till the refusal propagates a fear. Think
Neither fear nor courage saves us. Unnatural vices
Are fathered by our heroism. Virtues
Are forced upon us by our impudent crimes.
These tears are shaken from the wrath-bearing tree.

 The tiger springs in the new year. Us he devours.
 Think at last
We have not reached conclusion, when I
Stiffen in a rented house. Think at last
I have not made this show purposelessly
And it is not by any concitation
Of the backward devils.
I would meet you upon this honestly.
I that was near your heart was removed therefrom
To lose beauty in terror, terror in inquisition.

I have lost my passion: why should I need to keep it
Since what is kept must be adulterated?
I have lost my sight, smell, hearing, taste, and touch:
How should I use them for your closer contact?

These with a thousand small deliberations
Protract the profit of their chilled delirium,
Excite the membrane, when the sense has cooled,
With pungent sauces, multiply variety
In a wilderness of mirrors. What will the spider do,
Suspend its operations, will the weevil
Delay? De Bailhache, Fresca, Mrs. Cammel, whirled
Beyond the circuit of the shuddering Bear
In fractured atoms. Gull against the wind, in the windy straits
Of Belle Isle, or running on the Horn.
White feathers in the snow, the Gulf claims,
And an old man driven by the Trades
To a sleepy corner.

Tenants of the house,
Thoughts of a dry brain in a dry season.

T. S. ELIOT

monster but a man with understandable human failings, unhappy with the choice thrust upon him to alter human history.

The most moving devotional sections are those that revive ancient forms of Christmas poetry. The pastoral duet of angels and shepherds evokes the simple, untutored faith of the gospel rustics and preserves in graceful modern idiom the wonder of the ancient angelic song:

> Unto you a Child,
> A Son is given.
> Praising, proclaiming
> The ingression of Love,
> Earth's darkness invents
> The blaze of Heaven,
> And frigid silence
> Meditates a song.

The tender lullaby of Virgin to Christ child conveys the bittersweet quality of medieval Nativity laments in which Mary's joy at her son's birth was tempered by knowledge of his death:

> O shut your bright eyes that mine must endanger
> With their watchfulness; protected by its shade
> Escape from my care: what can you discover
> From my tender look but how to be afraid?
> Love can but confirm the more it would deny.
> Close your bright eye.

The final section of *For the Time Being* confronts the special nature of modern Christianity, at once reverent and prayerful, yet ridden with anxiety and doubt. The message of Auden's disembodied Narrator is not entirely hopeful, for he stops short of the traditional proclamation of joy in medieval Nativity drama. Instead, the Narrator voices a stoic admonition to the human soul to wait patiently for redemption, to "endure a silence" that may yet end in "triumph":

> The happy morning is over,
> The night of agony still to come; the time is noon:
> When the Spirit must practise his scales of rejoicing
> Without even a hostile audience, and the Soul endure
> A silence that is neither for nor against her faith
> That God's Will will be done, that, in spite of her prayers,
> God will cheat no one, not even the world of its triumph.

from FOR THE TIME BEING: A CHRISTMAS ORATORIO

ADVENT

I

Chorus

Darkness and snow descend;
The clock on the mantelpiece
Has nothing to recommend,
Nor does the face in the glass
Appear nobler than our own
As darkness and snow descend
On all personality.
Huge crowds mumble — "Alas,
Our angers do not increase,
Love is not what she used to be";
Portly Caesar yawns — "I know";
He falls asleep on his throne,
They shuffle off through the snow:
Darkness and snow descend.

Semi-Chorus

Can great Hercules keep his
Extraordinary promise
To reinvigorate the Empire?
Utterly lost, he cannot
Even locate his task but
Stands in some decaying orchard
Or the irregular shadow
Of a ruined temple, aware of
Being watched from the horrid mountains
By fanatical eyes yet
Seeing no one at all, only hearing
The silence softly broken
By the poisonous rustle
Of famishing Arachne.

Chorus

Winter completes an age
With its thorough levelling;
Heaven's tourbillions of rage

Abolish the watchman's tower
And delete the cedar grove.
As winter completes an age,
The eyes huddle like cattle, doubt
Seeps into the pores and power
Ebbs from the heavy signet ring;
The prophet's lantern is out
And gone the boundary stone,
Cold the heart and cold the stove,
Ice condenses on the bone:
Winter completes an age.

Semi-Chorus

Outside the civil garden
Of every day of love there
Crouches a wild passion
To destroy and be destroyed.
O who to boast their power
Here challenged it to charge? Like
Wheat our souls are sifted
And cast into the void.

Chorus

The evil and armed draw near;
The weather smells of their hate
And the houses smell of our fear;
Death has opened his white eye
And the black hole calls the thief
As the evil and armed draw near.
Ravens alight on the wall,
Our plans have all gone awry,
The rains will arrive too late,
Our resourceful general
Fell down dead as he drank
And his horses died of grief,
Our navy sailed away and sank;
The evil and armed draw near.

VISION OF THE SHEPHERDS

III

Chorus of Angels

Unto you a Child,
A Son is given.
Praising, proclaiming
The ingression of Love.
Earth's darkness invents
The blaze of Heaven,
And frigid silence
Meditates a song;
For great joy has filled
The narrow and the sad,
While the emphasis
Of the rough and big,
The abiding crag
And wandering wave,
Is on forgiveness:
Sing Glory to God
And good-will to men,
All, all, all of them.
Run to Bethlehem.

Shepherds

*Let us run to learn
How to love and run;
Let us run to Love.*

Chorus

Now all things living,
Domestic or wild,
With whom you must share
Light, water, and air,
And suffer and shake
In physical need,
The sullen limpet,
The exuberant weed,
The mischievous cat,
And the timid bird,

Are glad for your sake
As the new-born Word
Declares that the old
Authoritarian
Constraint is replaced
By His Covenant,
And a city based
On love and consent
Suggested to men,
All, all, all of them.
Run to Bethlehem.

Shepherds

*Let us run to learn
How to love and run;
Let us run to Love.*

Chorus

The primitive dead
Progress in your blood,
And generations
Of the unborn, all
Are leaping for joy
In your reins today
When the Many shall,
Once in your common
Certainty of this
Child's lovableness,
Resemble the One,
That after today
The children of men
May be certain that
The Father Abyss
Is affectionate
To all Its creatures,
All, all, all of them.
Run to Bethlehem.

AT THE MANGER

I

Mary

O shut your bright eyes that mine must endanger
With their watchfulness; protected by its shade
Escape from my care: what can you discover
From my tender look but how to be afraid?
Love can but confirm the more it would deny.
 Close your bright eye.

Sleep. What have you learned from the womb that bore you
But an anxiety your Father cannot feel?
Sleep. What will the flesh that I gave do for you,
Or my mother love, but tempt you from His will?
Why was I chosen to teach His Son to weep?
 Little One, sleep.

Dream. In human dreams earth ascends to Heaven
Where no one need pray nor ever feel alone.
In your first few hours of life here, O have you
Chosen already what death must be your own?
How soon will you start on the Sorrowful Way?
 Dream while you may.

THE FLIGHT INTO EGYPT

III

Narrator

Well, so that is that. Now we must dismantle the tree,
Putting the decorations back into their cardboard boxes —
Some have got broken — and carrying them up to the attic.
The holly and the mistletoe must be taken down and burnt,
And the children got ready for school. There are enough
Left-overs to do, warmed-up, for the rest of the week —
Not that we have much appetite, having drunk such a lot,
Stayed up so late, attempted — quite unsuccessfully —
To love all of our relatives, and in general

Grossly overestimated our powers. Once again
As in previous years we have seen the actual Vision and failed
To do more than entertain it as an agreeable
Possibility, once again we have sent Him away,
Begging though to remain His disobedient servant,
The promising child who cannot keep His word for long.
The Christmas Feast is already a fading memory,
And already the mind begins to be vaguely aware
Of an unpleasant whiff of apprehension at the thought
Of Lent and Good Friday which cannot, after all, now
Be very far off. But, for the time being, here we all are,
Back in the moderate Aristotelian city
Of darning and the Eight-Fifteen, where Euclid's geometry
And Newton's mechanics would account for our experience,
And the kitchen table exists because I scrub it.
It seems to have shrunk during the holidays. The streets
Are much narrower than we remembered; we had forgotten
The office was as depressing as this. To those who have seen
The Child, however dimly, however incredulously,
The Time Being is, in a sense, the most trying time of all.
For the innocent children who whispered so excitedly
Outside the locked door where they knew the presents to be
Grew up when it opened. Now, recollecting that moment
We can repress the joy, but the guilt remains conscious;
Remembering the stable where for once in our lives
Everything became a You and nothing was an It.
And craving the sensation but ignoring the cause,
We look round for something, no matter what, to inhibit
Our self-reflection, and the obvious thing for that purpose
Would be some great suffering. So, once we have met the Son,
We are tempted ever after to pray to the Father;
"Lead us into temptation and evil for our sake."

They will come, all right, don't worry; probably in a form
That we do not expect, and certainly with a force
More dreadful than we can imagine. In the meantime
There are bills to be paid, machines to keep in repair,
Irregular verbs to learn, the Time Being to redeem
From insignificance. The happy morning is over,
The night of agony still to come; the time is noon:
When the Spirit must practise his scales of rejoicing
Without even a hostile audience, and the Soul endure
A silence that is neither for nor against her faith
That God's Will will be done, that, in spite of her prayers,
God will cheat no one, not even the world of its triumph.

IV

Chorus

He is the Way.
Follow Him through the Land of Unlikeness;
You will see rare beasts, and have unique adventures.

He is the Truth.
Seek Him in the Kingdom of Anxiety;
You will come to a great city that has expected your return for
 years.

He is the Life.
Love Him in the World of the Flesh;
And at your marriage all its occasions shall dance for joy.

W. H. AUDEN

More than any other poet of our century, Auden dramatizes the prismatic quality of modern religious experience. He affirms that the ambiguity and suffering of our time are a valuable, even necessary corollary to faith and, like Reinhold Niebuhr, finds solace in the conviction that "man is most free in the discovery that he is not free."

THE LEGACY OF WAR

On September 1, 1939, Hitler invaded Poland. Two days later, England declared war on Germany. Over the next year, fighting engulfed nearly all of Europe and North Africa, while Hitler's Luftwaffe rained bombs on a London courageously girded for "blood, toil, tears and sweat." By December 1941, America, too, had entered the fray as Japan inaugurated a "lightning war" of its own over the eastern portion of the globe. With World War II as their backdrop, the British poet Edith Sitwell and the American poet Allen Tate use the scriptural Nativity as a religious and moral ideal against which to measure the chaos of war-torn nations. In these bleak, prophetic poems, the Nativity no longer appears as a religious symbol evoking divine concerns, but as a cultural one reflecting human depravity and political corruption.

Sitwell in her memoirs describes wartime London as a "world in shadow, although the passing sound of that far-off music among the ruins was forever with us." The "far-off" music of a lost and humane past played an ironic counterpoint to a terrifying real-life noise — the whine of German bombs dropping on the civilians in London. Once, during a poetry reading to a group of servicemen on holiday, she heard

> the familiar, heart-stopping whine of a doodlebug. Perhaps everybody in that room wondered whether we should throw ourselves under tables or just run for our lives. I went on reading and the bomb passed overhead.

Even death may breed familiarity, but the anguish of living under such violent conditions eventually takes its toll. Sitwell would never forget that "heart-stopping whine." That noise was to inspire her famous crucifixion lament, "Still Falls the Rain" and its companion piece on the Nativity, "Lullaby," two of the finest contemporary poetic protests against war. "Lullaby" is a grisly parody of a medieval Nativity lyric exploring the real suffering of Londoners during the blitz. In chastising the violence of wartime England, she mocks the old religious symbols themselves. This is no holy birth, no promise of a glorious peace. The Luftwaffe

raids spawn an ironic cradle scene in which an ape croons a song of death to a frighteningly enigmatic child amidst the conflagrations of war:

> She sat in the hollow of the sea —
> A socket whence the eye's put out —
> She sang to the child a lullaby
> (The steel birds' nest was thereabout).
>
> "Do, do, do, do —
> Thy mother's hied to the vaster race:
> .
> And I am come to take her place
> Do, do."

Like the theologian Martin Heidegger, Sitwell views man as a "being towards death," a poor creature facing an urgent "eschatological moment" at which Christ must be chosen or doom assured. An equally devastating perspective on humanity lies at the heart of Allen Tate's Nativity poems, although here it is moral lethargy rather than man's penchant for violence that Tate eschews. In his prewar *Sonnets at Christmas* (1934), Tate makes the Nativity a symbol for the poet's personal sense of sin. Sonnet I describes the poet's vague feelings of mortality initiated by Christ's "Hour of Life." In Sonnet II, a line from Tennyson's jubilant *In Memoriam* Christmas lyric triggers painful recollections of a childhood crime:

> Ah, Christ, I love you rings to the wild sky
> And I must think a little of the past:
> When I was ten I told a stinking lie
> That got a black boy whipped.

More Sonnets at Christmas (1943), written during World War II, uses the Nativity as a cultural symbol reflecting the anomie of a secular age, or what the theologian-critic Nathan Scott describes as "a great impoverishment of the human spirit, resulting in a general banalization of the world and experience." The sonnets indict a wartime American society reeking with hypocrisy and empty values. It is a society that keeps its traditional religious holidays and mouths the familiar cliches, but lacks the spiritual gifts to make seasonal festivities come alive. Sonnet II explores the selfish intelligence of the American businessman, cold-bloodedly calculating the conquering of foreign nations in a devastatingly commonplace Christmas party scene. Sonnet III castigates the self-righteous, pseudoreligious

STILL FALLS THE RAIN

The Raids, 1940. Night and Dawn

Still falls the Rain —
Dark as the world of man, black as our loss —
Blind as the nineteen hundred and forty nails
Upon the Cross.

Still falls the Rain
With a sound like the pulse of the heart that is changed to the
 hammer-beat
In the Potter's Field, and the sound of the impious feet

On the Tomb:
 Still falls the Rain
In the Field of Blood where the small hopes breed and the human
 brain
Nurtures its greed, that worm with the brow of Cain.

Still falls the Rain
At the feet of the Starved Man hung upon the Cross.
Christ that each day, each night, nails there, have mercy on us —
On Dives and on Lazarus:
Under the Rain the sore and the gold are as one.

Still falls the Rain —
Still falls the Blood from the Starved Man's wounded Side:
He bears in His Heart all wounds — those of the light that died,
The last faint spark
In the self-murdered heart, the wounds of the sad
 uncomprehending dark,
The wounds of the baited bear —
The blind and weeping bear whom the keepers beat
On his helpless flesh . . . the tears of the hunted hare.

Still falls the Rain —
Then — O Ile leape up to my God: who pulles me doune —
See, see where Christ's blood streames in the firmament:
It flows from the Brow we nailed upon the tree

177

Deep to the dying, to the thirsting heart
That holds the fires of the world — dark-smirched with pain
As Caesar's laurel crown.

Then sounds the voice of One who like the heart of man
Was once a child who among beasts has lain —
"Still do I love, still shed my innocent light, my Blood, for thee."

EDITH SITWELL

LULLABY

Though the world has slipped and gone,
Sounds my loud discordant cry
Like the steel birds' song on high:
"Still one thing is left — the Bone!"
Then out danced the Babioun.

She sat in the hollow of the sea —
A socket whence the eye's put out —
She sang to the child a lullaby
(The steel birds' nest was thereabout).

"Do, do, do, do —
Thy mother's hied to the vaster race:
The Pterodactyl made its nest
And laid a steel egg in her breast —
Under the Judas-colored sun.
She'll work no more, nor dance, nor moan,
And I am come to take her place
Do, do.

There's nothing left but earth's low bed —
(The Pterodactyl fouls its nest):
But steel wings fan thee to thy rest,
And wingless truth and larvae lie
And eyeless hope and handless fear —
All these for thee as toys are spread,

Do — do —
Red is the bed of Poland, Spain,
And thy mother's breast, who has grown wise
In that fouled nest. If she could rise,
Give birth again,
In wolfish pelt she'd hide thy bones
To shield thee from the world's long cold,
And down on all fours shouldst thou crawl
For thus from no height canst thou fall —
Do, do.

She'd give no hands: there's nought to hold
And nought to make: there's dust to sift,
But no food for the hands to lift.
Do, do.

Heed my ragged lullaby,
Fear not living, fear not chance;
All is equal — blindness, sight,
There is no depth, there is no height:
Do, do.

The Judas-colored sun is gone,
And with the Ape thou art alone —
Do,
 Do."

EDITH SITWELL

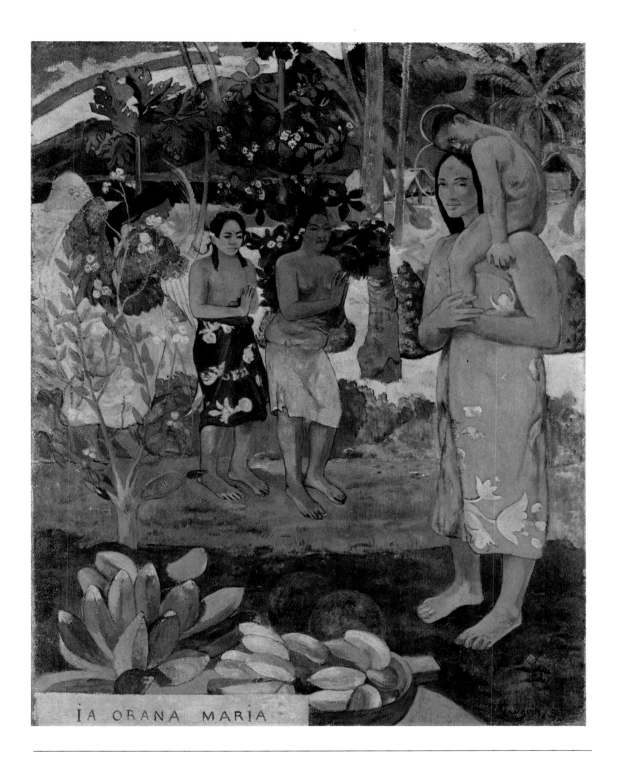

IA ORANA MARIA

CHRIST CLIMBED DOWN

Christ climbed down
from His bare Tree
this year
and ran away to where
there were no rootless Christmas trees
hung with candycanes and breakable stars

Christ climbed down
from His bare Tree
this year
and ran away to where
there were no gilded Christmas trees
and no tinsel Christmas trees
and no tinfoil Christmas trees
and no pink plastic Christmas trees
and no gold Christmas trees
and no black Christmas trees
and no powderblue Christmas trees
hung with electric candles
and encircled by tin electric trains
and clever cornball relatives

Christ climbed down
from His bare Tree
this year
and ran away to where
no intrepid Bible salesmen
covered the territory
in two-tone cadillacs
and where no Sears Roebuck creches
complete with plastic babe in manger
arrived by parcel post
the babe by special delivery
and where no televised Wise Men
praised the Lord Calvert Whiskey

Christ climbed down
from His bare Tree
this year
and ran away to where
no fat handshaking stranger
in a red flannel suit
and a fake white beard
went around passing himself off
as some sort of North Pole saint
crossing the desert to Bethlehem
Pennsylvania
in a Volkswagen sled
drawn by rollicking Adirondack reindeer
with German names
and bearing sacks of Humble Gifts
from Saks Fifth Avenue
for everybody's imagined Christ child

Christ climbed down
from His bare Tree
this year
and ran away to where
no Bing Crosby carollers
groaned of a tight Christmas
and where no Radio City angels
iceskated wingless
thru a winter wonderland
into a jinglebell heaven
daily at 8:30
with Midnight Mass matinees

Christ climbed down
from His bare Tree
this year
and softly stole away into

some anonymous Mary's womb again
where in the darkest night
of everybody's anonymous soul
He awaits again
an unimaginable

and impossibly
Immaculate Reconception
the very craziest
of Second Comings

LAWRENCE FERLINGHETTI

THE HOLY INNOCENTS

Listen, the hay-bells tinkle as the cart
Wavers on rubber tires along the tar
And cindered ice below the burlap mill
And ale-wife run. The oxen drool and start
In wonder at the fenders of a car,
And blunder hugely up St. Peter's hill.
These are the undefiled by woman — their
Sorrow is not the sorrow of this world:
King Herod shrieking vengeance at the curled
Up knees of Jesus choking in the air,

A king of speechless clods and infants. Still
The world out-Herods Herod; and the year,
The nineteen-hundred forty-fifth of grace,
Lumbers with losses up the clinkered hill
Of our purgation; and the oxen near
The worn foundations of their resting-place,
The holy manger where their bed is corn
And holly torn for Christmas. If they die,
As Jesus, in the harness, who will mourn?
Lamb of the shepherds, Child, how still you lie.

ROBERT LOWELL

Twentieth-century sculptors and painters display the same deeply personal attitude to the Nativity as Lowell, Hughes, and Ferlinghetti. Unlike the "beautiful madonnas" and the richly illuminated, emblematic Nativity scenes of former centuries, there no longer exists a scripturally faithful vision common among artists. Each modern artist employs contemporary infants and mothers as models for Mary and Jesus. Each artist speaks as a solitary individual to a huge international audience. The Nativity has become as much a racial and political myth as a religious one in a densely populated world whose boundaries have suddenly shrunk.

Ideas are the poet's and artist's coin, minted anew by the intelligentsia of every age. However, the ideology of the common folk is another matter. Naive copies of older forms of Nativity verse, sculpture, and painting have grown and flourished amid the welter of Christmas greeting cards, Sunday School texts, and popular literature of this century. These anachronistic, sometimes sentimental representations of the birth of Christ attest to the survival of an age-old devotion among masses of men and women whose simple, earnest, Bible-centered faith may not happen to be the stuff of belles lettres.

By contrast, the aesthetes and thinkers of our age look upon the Nativity as a compelling, quintessentially modern theme. Twentieth-century poets and artists wander far afield from the original gospel narratives in their depiction of Christ's birth. Yet the reappearance of the theme at the forefront of modern poetry and plastic arts after over two centuries of disuse confirms the Nativity's continuing richness and its remarkable capacity to reflect the distinguishing characteristics of even this complex, worldly era.

Plate 25. *Mary Cassatt,* The Bath *(1892)*
In Cassatt's painting, only the natural affection and hushed intimacy of mother and child recall the Madonnas of an earlier age. Despite its secular manifestations and idiosyncratic treatment, however, the theme of the Nativity continues to assert itself in contemporary poetry and art. Art Institute, Chicago (Scala, New York/Florence)

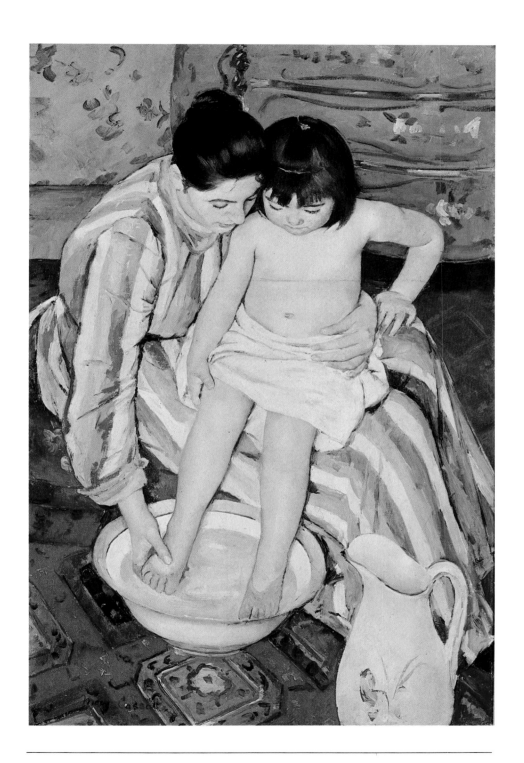